Peckham & Nunhead
Residents and Visitors

Peckham & Nunhead
Residents and Visitors

John D. Beasley

AMBERLEY

First published 2012

Amberley Publishing
The Hill, Stroud
Gloucestershire, GL5 4EP

www.amberley-books.com

British Library Cataloguing in Publication Data.
A catalogue record for this book is available from the British Library.

ISBN 978 1 84868 872 8

Typeset in 10pt on 12pt Sabon.
Typesetting and Origination by Amberley Publishing.
Printed in the UK.

Contents

Introduction

Though I am a proud Yorkshireman, this year I celebrated forty years as a Peckham resident. A fellow Yorkshireman Tim Charlesworth, who lives in a house overlooking Peckham Rye Common, wrote *The Architecture of Peckham* and *The Story of Burgess Park*. The owner of the sports factory opened in the nineteenth century close to Peckham Rye Station, George Bussey, was also born in Yorkshire. At least four Yorkshire-born people live within 100 metres of my home in Everthorpe Road.

In *Camberwell Place and Street Names and their Origin* Leslie S. Sherwood wrote: 'EVERTHORPE ROAD, 1902. (Formerly Normanton Terrace.) Probably after a hamlet in Yorkshire, like its former name.'

Numbers 1–11 Everthorpe Road were originally 1–6 Normanton Terrace. Numbers 2–10 were built in 1882 and named Placquett Terrace.

I have a photograph of my family taken next to an Everthorpe Road sign in the East Riding of Yorkshire.

Who Was Who in Peckham, published in 1985 by Chener Books of Lordship Lane, was my second book on Peckham. The first was *The Story of Peckham*, an eighteen-page booklet for children published by the London Borough of Southwark in their 'Neighbourhood Histories' series. Most of the others were written by Mary Boast, Southwark's first Local Studies Librarian. As a consequence of a conversation with her I started writing books on Peckham.

In 1972, the year I moved to Peckham from Camberwell Grove (with a broken arm after playing football!), I started a two year social work course at the Polytechnic of North London. The first essay we were invited to do was on social history. I thought about writing an essay on William Wilberforce, the leading campaigner against the slave trade. He was born in Hull, fifteen miles from Hornsea* on the Yorkshire coast where I was born.

However, as I had recently moved to Peckham I decided that it was a good opportunity to learn some Peckham history. I therefore wrote an essay on Peckham in the nineteenth century. It was the biggest piece of work I did at the Polytechnic even

though it was not part of the work I had to do in order to obtain my Certificate of Qualification in Social Work.

All the twenty plus books I have written on Peckham and other parts of the London Borough of Southwark, and 300 articles for the *South London Press*, stemmed from that essay. When I was only two, my parents, sisters and I moved to Grimsby in Lincolnshire. When I was a pupil at Wintringham Boys' Grammar School, where I spent the five longest years of my life, I hated history and came bottom of the class with 29% in the last exam in history I sat at school. I also failed 'O' level English Language with the lowest failure grade.

In 1960, at the age of fifteen, I came to London to work at the Westminster headquarters of the charity that is now Hope UK, a national drug education organisation for which I am a Voluntary Educator. My boss was Robert Tayler who had been minister of Hanover Chapel in Bellenden Road, Peckham. He was the best teacher I ever had. He was an author and editor who taught me writing skills. He also encouraged me to spend four years in my leisure time studying for a London University Diploma in Sociology. The first year was on social history which I found interesting and fascinating.

Over the years I have compiled an unpublished Peckham and Nunhead Biographical Dictionary, including sources. A copy is in the highly acclaimed Southwark Local History Library, 211 Borough High Street, London SE1 1JA (Tel: 020 7525 0232). That has provided much information for this book. In addition I have collected a huge number of cuttings from *Southwark News*, the *South London Press* and many other sources.

Though not everyone who has travelled through Peckham on a number 36 bus is mentioned in this book, a wide variety of Peckham and Nunhead residents and visitors are among over 500 people featured including actor Jeremy Irons who said: 'I had a great year of my life in Peckham.'

*While staying in Hornsea writer Winifred Holtby, author of *South Riding*, wrote about the Peckham Pioneer Health Centre.

Robert Tayler – 'the best teacher I ever had'.

Cricketer **Robert Abel** (1857–1936) played on Peckham Rye what was probably his first proper match when he was about fifteen; he was bowled out first ball. He was chosen as *Wisden's* Cricketer of the Year in 1890. He was a master batsman who made 357 not out for Surrey against Somerset at the Oval in 1899. He played his last test match for England in 1902. He was buried in Nunhead Cemetery.

Newton Aduka studied at the London International Film School and lived on the North Peckham Estate. He has made various films including *On the Edge* and *Rage*.

Adam Afriyie, who was the first black Conservative MP, attended Oliver Goldsmith School.

A book plate shows that **John Yonge Akerman** (1806–73) lived in Peckham in 1834. In 1836 he launched the *Numismatic Journal*.

The Daily Telegraph on 11 January 1997 included an article about professional boxer **Henry Akinwande** who spent hours shadow boxing in his Peckham council flat.

HRH Prince Albert (1819–61), Prince Consort to Queen Victoria, visited the Licensed Victuallers' Asylum (now Caroline Gardens).

HRH Princess Alexandra visited Pelican House, the premises of the London Association for the Blind on 27 February 1961. She also opened Peckham police station on 10 March 1988, after it was rebuilt.

HRH Princess Alexandra Victoria, Duchess of Fife (1891–1959), who was generally known as HRH Princess Arthur of Connaught, opened a Church Army housing estate in Bellenden Road on 9 May 1933.

HRH Princess Alice (Countess of Athlone) (1883–1981) attended the consecration of St Luke's Church on 18 October 1954.

George Allen (1872–1962) was born in Peckham and attended Stafford Street Wesleyan School. He became a Methodist Minister and was Connexional Secretary of the Wesley Guild.

William Alsop and his colleagues in Alsop & Störmer Architects designed Peckham Library which in 2000 won the Stirling Prize for the building of the year. *See* **Chris Smith**.

Scriptwriter **Andrew Alty** of Lyndhurst Way wrote for *The Bill*.

Sharon Ament, who will be the new Director of the Museum of London in September 2012, lived at 47 Consort Road for the first few years of her life.

The Columbian Minister of Culture, **Maria Consuelo Araujo**, visited Peckham Library in March 2004.

Ellen Armstrong of Oglander Road was named in 2003 as one of the UK's most inspiring women for helping prostitutes. She was runner-up in a competition run by the magazine *Marie Claire*.

Robert Archibald Armstrong (1788–1867) compiled *A Gaelic Dictionary*, the first ever published. He lived at Hanover House, Choumert Road.

Victoria Armstrong (1909–98) attended Peckham Rye Elementary School for Girls and became an HM Inspector of Schools. She was awarded an MBE for services in social work in South London.

Actor **Mark Asante**, who lived at 45 Stanbury Road, has appeared in films, on television and in stage productions including *The Bill*, *Chuckle Vision*, *The Riddle*, *Messiah: The Rapture* and *Occupation*.

Prince Albert laid the foundation stone for a new wing of the Licensed Victuallers' Asylum.

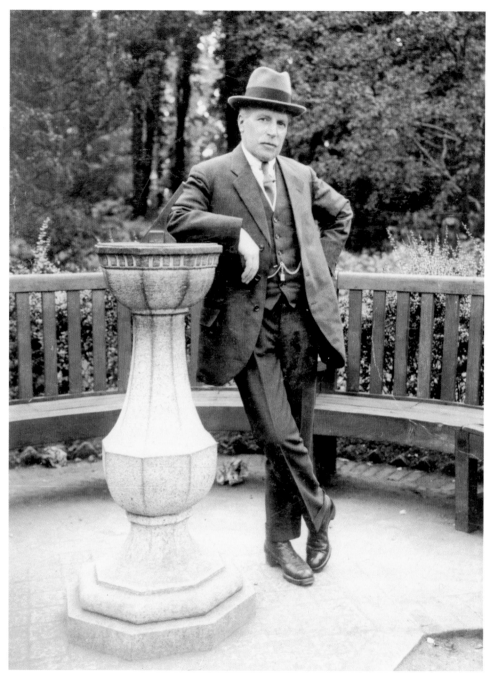

Arthur Ashmore posed next to a sundial in Peckham Rye Park.

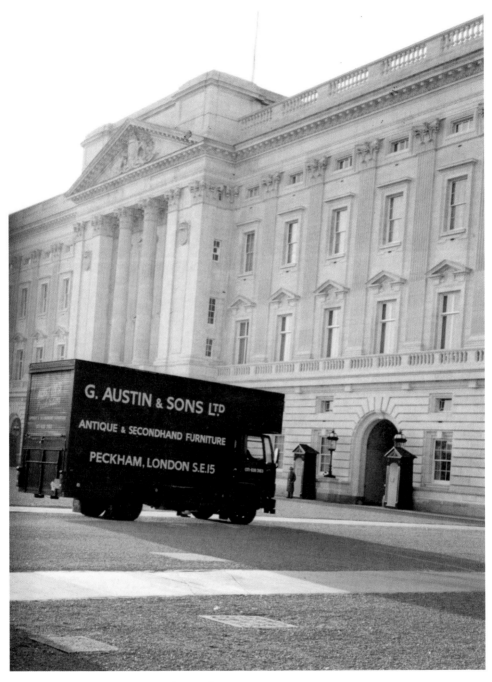

An Austin's van went to Buckingham Palace.

In *Beyond Westminster: Finding Hope in Britain* **Paddy Ashdown** (now **Baron Ashdown of Norton-Sub-Hamden**) described a visit to Peckham he made on 24 November 1992.

When **Jack Ashley** (later **Lord Ashley of Stoke** 1922–2012) was an MP he visited Peckham Park Road Junior School in November 1980 and opened a new library.

Arthur John Ashmore (1865–1959) was the first Superintendent of Peckham Rye Park.

Nancy, Viscountess Astor (1879–1964) on 10 December 1935 officially opened the first nursery school to be built in Peckham. It was run by the Union of Girls' Schools for Social Service in Staffordshire Street (now the Peckham Settlement).

Clement Attlee (1883–1967) when he was Prime Minister went to the Odeon theatre in Peckham High Street to see *The Centre*, a film about the Peckham Pioneer Health Centre, on 12 July 1948. He and his wife then visited the centre in St Mary's Road.

Derek and **Valerie Austin** were the last members of their family to run Austin's, which closed in 1994.

George Austin (1844–1925) founded Austin's of Peckham where Austin's Court was built. It was one of the largest antique and second-hand dealers in Europe.

Margaret Austin (1804–40) was the wife of the Revd John Baptist Austin, a Nonconformist minister of Goldsmith House (which was at the corner of what are today Goldsmith Road and Staffordshire Street). She was the first person to be buried in the unconsecrated or Dissenters' ground at Nunhead Cemetery.

Ayak, a singer-songwriter who was born in Sudan and lived most of her life in Peckham, has enjoyed a string of chart hits.

The 1958 film *The Inn of the Sixth Happiness* was about the missionary **Gladys Aylward**. She visited Peckham Methodist Church and was photographed with the minister, the Revd Bernard Sewell, who served there from 1953 to 1958.

In 1955 baker **John Frederick Ayre** (1927–85) established his firm when he purchased a bakery and shop at 133 Evelina Road.

Bollywood actor **Amitabh Bachchan** carried the Olympic Flame in Peckham on 26 July 2012.

Chief Constable Matt Baggott of the Police Service of Northern Ireland was a Superintendent at Peckham police station.

Derbyshire born **Ezekiel James Bailey** was a builder whose legacy includes Christ Church, McDermott Road, and Placquett Terrace (now 2–10 Everthorpe Road).

Actress **Dame Beryl Bainbridge** was a customer at Austin's of Peckham Rye.

Artist **Doug Baker** (1921–2005) lived at 17 Howbury Road. *Drawing a Line from Here and There* features his work. He drew the prize winning poster to publicise the Peckham Rye Park centenary celebrations in 1994.

The world's leading expert on the founder of Methodism John Wesley, **Professor Frank Baker** (1910–99), preached at Peckham Methodist Church in 1988.

For 35 years the **Revd Theo Bamber** (1891–1970) was pastor of Rye Lane Chapel. On Winston Churchill's invitation, he went to see Churchill in his bunker in Whitehall during the Second World War. A potted biography of Theo Bamber is in *Origin of Place Names in Peckham and Nunhead* under Bamber Road.

Frederick Banbury, MP (1850–1936), who became a Peer, attended the stone laying at Nunhead Library on 11 April 1896.

Banksy, a guerrilla artist, in 2005 left a painting on a piece of rock from Peckham in the British Museum's gallery of artefacts from Roman Britain. On the stone was a drawing of a primitive man pushing a supermarket trolley.

England footballer **John Barnes** visited Bredinghurst School in 2005.

In *London Echoing* (pub. 1948) James Bane wrote: 'If not the last, **Mr Gray Barton** of Peckham must count as one of the last quill penmakers in London.'

Singer **Shirley Bassey** was a customer at Austin's of Peckham Rye.

Film director **Scott Bates** swapped the streets of his native Peckham for the red carpets of Leicester Square on 22 September 2011 for the premiere of his first film *The Tapes*.

Photographer and designer **Sir Cecil Beaton** (1904–80) was an Austin's of Peckham Rye customer.

Norman Beaton came here.

Actor **Norman Beaton** (1934–94) was the barber in the comedy *Desmond's* based on a barber's shop at 204 Bellenden Road. Biographical information about Norman Beaton is in *Origin of Place Names in Peckham and Nunhead* under Beaton Close.

Princess Beatrix, who became Queen of the Netherlands, was a customer at Austin's of Peckham Rye and had coffee with Derek and Valerie Austin in their office.

Costume designer **Jenny Beavan** lives in Peckham. In an interview in *Radio Times* (26 February–4 March 2011) it was stated that she has dressed Jude Law and Kate Winslet. She won an Oscar for *A Room with a View*.

Frances Beckett lives in Montpelier Road. She became Chief Executive of the Church Urban Fund in 2002 and received an OBE in 2006.

John Warburton Beckett (1894–1964), who was the MP for Peckham in 1929–31, seized the Mace in the House of Commons in 1930.

Pugilist **Thomas Belcher** (1783–1854) was a prize fighter. He died at his home, 19 Trafalgar Square, Peckham (close to where Buller Close is today).

Athlete **Floella Benjamin** was in the procession when the Olympic Flame was carried along Peckham High Street and Queen's Road on 26 June 2004.

Former MP **Tony Benn** spoke in Philip Walk on 25 October 2009 after a blue plaque commemorating Edward Turner (q.v.) was unveiled.

Ann Bernadt (1948–96) was born in South Africa and became a Southwark Councillor for Lane Ward, Peckham. The Ann Bernadt Nursery School and Early Learning Centre in Chandler Way was opened by Harriet Harman, MP on 2 December 1997.

Oliver Percy Bernard (1881–1939) was born at No. 2 Box Villas (now 91) Danby Street. He was a journalist, furniture designer, engineer and a master of art deco architecture. He was a consultant for the British Empire Exhibition in 1924 and redesigned the interiors of the Cumberland, Strand Palace and Regent Palace Hotels.

Footballer **Ryan Bertrand** grew up in Peckham on the Friary Estate. He was a member of the Chelsea team who won the European Champions League Trophy on 19 May 2012.

Poet **Sir John Betjeman** (1906–84) opened the Livesey Museum in the Old Kent Road in 1974.

Robert Bigsby (1806–73) owned the astrolabe constructed for Captain Francis Drake prior to his expedition to the West Indies in 1570. Robert Bigsby wrote seventeen books. He died in 1873 at 4 Beaufort Terrace, Peckham Rye.

Linda Binder, who attended Peckham School, has lived in the USA for forty years. In 1998 she was elected as a member of the House of Representatives and in 2000 was elected on to the Senate in Arizona. She learnt to ride a bicycle in Peckham Rye Park and worked in two Rye Lane shops – C & A and Woolworth's.

The Director-General of the Tree Council, **Pauline Buchanan Black** who lives in Oglander Road, correctly identified the five trees planted to mark the centenary of Peckham Rye Park. The trees were originally incorrectly named. They are the maple *Acer cappadocicum* commonly known as the Caucasian maple. They are situated behind the plaque unveiled on the Park's centenary day – Saturday 14 May 1994 – by the Mayor of Southwark, Councillor Cecile Lothian.

Baroness Blackstone visited the former chapel in Caroline Gardens, in Asylum Road, in 2001.

Tony Blair, MP, attended the Peckham Rye Gala in 1987, visited Sumner House in 1996, spoke at the Damilola Taylor Centre in 2001, visited Churchill Court off Blenheim Grove in 2005, and visited the Ledbury Estate in 2006.

Former offender and gang member **Jennifer Blake**, who grew up in Peckham, founded the Eternal Life Support Centre in 2004 to offer advice and counselling to young people in SE15.

William Blake (1757–1827), who became a poet and a painter, visited Peckham Rye when he was a child and had his first vision of 'a tree filled with angels, bright angelic wings bespangling every bough like stars'.

Amy Blakemore wrote a poem about the streets of Peckham when she was fifteen. This made her one of fifteen writers named Foyle Young Poets of the Year in 2007. She competed with nearly 10,000 teenagers from around the world.

William Harnett Blanch (1836–1900) wrote *Ye Parish of Camerwell* published in 1875. He lived at 11 Denman Road; this became number 55 in 1874. More biographical information is in *Origin of Place Names in Peckham and Nunhead* under Blanch Close.

Peter Bleksley wrote *Ten Most Wanted* and *Gangbusters*. He joined the Metropolitan Police in 1978 and his first posting was to Peckham police station.

David Blunkett, MP, unveiled a plaque in 1993 at 69 Bellenden Road used by Southwark Phoenix Women's Health Organisation. The building was named Sally Mugabe House in memory of the First Lady of Zimbabwe. She visited Southwark in 1987.

Paul Boateng, MP (now **Lord Boateng**) was an *Any Questions?* panel member for the BBC at the North Peckham Civic Centre in 1989. He also preached at Peckham Methodist Church on 28 May 1995 when he highlighted the damaging effects of consumerism on the environment.

In 1857 **James George Stuart Burges Bohn** (1803–80) prepared a catalogue of theological books in foreign languages which was a volume of 704 pages. He died at his home, 10 Cambridge Terrace, Victoria Road (now Bellenden Road) in 1880.

Sir Thomas Bond (?–1685) purchased an estate in Peckham belonging to Sir Thomas Grymes whose sister he had married. He had Peckham Manor House built; this was on the west side of where Peckham Hill Street is today.

Dr James Ebenezer Boon (1867–1941) made history on Sunday 30 July 1922 when he preached the first sermon broadcast by radio in Britain to his congregation at Christ Church, McDermott Road.

Catherine Booth (1829–90), wife of Salvation Army founder William Booth, began a ten week series of meetings in February 1866 in the Rosemary Branch Assembly Rooms, Southampton Street (now Way).

Cherie Booth, wife of Tony Blair (q.v.), visited Peckham on 29 November 1996 and learnt about energy-efficient methods being used in new housing in North Peckham.

Paul Boateng preached in Peckham Methodist Church.

Stephen Bourne received a Southwark Civic Award in St Giles's Church, Camberwell.

Viscount Borodale unveiled portraits of George Randell Higgins (q.v.) and Edwin Jones (q.v.) at the South London Art Gallery on 12 October 1933.

Author **Stephen Bourne** was brought up at 151 Cronin Road. He spent much of his childhood watching films in the Odeon cinema in Peckham High Street. He is one of the leading authorities on the history of black people in Britain.

Thomas Gibson Bowles (1842–1922) attended Mr Cobley's preparatory school in Peckham Rye. In 1868 he started a society paper called *Vanity Fair*. He later became an MP.

Sir John Boyd (1917–89) became General Secretary of the Amalgamated Union of Engineering Workers at 110 Peckham Road in 1975. (This is now Peckham Lodge.)

Charlotte Amelia Bracey-Wright (1841–1939), the Countess de Lormet, represented North Peckham on the Camberwell Vestry. She served on Camberwell Borough Council (1919–34) and was a member of Camberwell Board of Guardians.

George William Wilshere Bramwell (1808–92) attended Dr Martin Ready's school in the High Street opposite Rye Lane. He became a judge in 1856 as a Baron of the Exchequer. He was created Lord Bramwell in 1881.

William Brenchley (1858–1938) spent almost fifty years in public service in the Metropolitan Borough of Camberwell and was Mayor (1911–12). He was a teacher at Bellenden Road School and in 1906 became headmaster of Wood's Road School (now John Donne School).

Harold Bride (1890–1956), who was born at Nunhead, trained as a Marconi operator. He joined the *Titanic* at Southampton on 9 April 1912 and was rescued when she was sinking.

George Polgreen Bridgetower (1779–1860) was a notable violinist who lived at 8 Victory Cottages, Bedford Street (now Sandison Street). He died there.

Pop star **Katy B**, whose real name is **Kathleen Anne Brien**, grew up in Peckham. She was photographed in Peckham Square in the *Guardian* on 30 March 2011.

Peckham Rye, cockney rhyming slang for tie, is the name of a West End shop owned by **Martin Brighty** which specialises in ties. He grew up in Queen's Road.

Charles Thomas Brock (1843–81) had a firework factory at Nunhead. He organised impressive firework displays at the Crystal Palace. More biographical information is included in *Origin of Place Names in Peckham and Nunhead* under Brock Street.

Sir Benjamin Collins Brodie (1783–1862) was sergeant-surgeon to William IV and Queen Victoria. Before becoming a baronet in 1834, he lived for some time at Myrtle House, 13 Queen's Road.

George Brown (1914–85), who became **Lord George-Brown**, made a controversial speech at the opening of the Acorn Estate on 20 July 1963.

Gordon Brown, MP, who became Prime Minister, visited Peckham Library and Peckham Pulse in 2000. He and Prime Minister Tony Blair (q.v.) visited Churchill Court, Blenheim Grove, in 2005.

Artist **Stuart Brown** made over a hundred sketches of the Peckham area. Many have been published in *Peckham Society News*.

Timothy Brown (1744–1820) lived at Peckham Lodge, Rye Lane. Part of the Jones & Higgins store was built on the site. Timothy Brown was a paper merchant and was one of the founders of the Union Society, an important Reform society founded in 1816.

Poet **Robert Browning** (1812–89) attended a boarding school in the High Street, Peckham.

William Bryant (1804–74), co-founder of the match making firm Bryant & May, attended the Peckham Quaker Meeting House in Hanover Street (now part of the Royal Mail Delivery Office in Highshore Road).

International basket-baller **Steve Bucknell** visited the Damilola Taylor Centre on 13 April 2006. He displayed the medal he won for England at the previous month's Commonwealth Games in Melbourne.

Actor **John Baldwin Buckstone** (1802–79) made his first theatrical appearance in the Peckham Theatre in the High Street.

James Bunstone Bunning (1802–63) designed the neo-classical gate lodges at Nunhead Cemetery and laid out the cemetery which opened in 1840.

David Burch (1941–2002) was a Southwark Council artist who designed and illustrated *The Story of Peckham*, first published in 1976.

Actor **Alfred Burke** (1918–2011) lived at 22 Kincaid Road and attended Leo Street Boys' School.

Surrey cricketer **Charles William Burls** (1847–1923) was born at Peckham Rye.

Andy Burnham, MP visited Peckham police station in 2006 to outline new powers in the proposed Violent Crime Reduction Bill.

Metalwork artist **Heather Burrell** designed the gates on the Centre for Wildlife Gardening in Marsden Road.

Alistair Burt, MP opened the Benefit Agency office in Collyer Place in 1994.

Yorkshireman **George Gibson Bussey** (?1829–89) ran a sports factory in the nineteenth century, which still exists close to Peckham Rye Station.

Newspaper tycoon Rupert Murdoch described Peckham-born **Frank Butler** (1916–2006) as 'the best sports writer in the history of Fleet Street'. He worked for the *News of the World* for thirty-three years.

Former Lugard Road resident **Ray Byfield** spent seven years making a model of the Royal Arsenal Co-operative Society's store at 125–135 Queen's Road.

Feckham Peckham by **Joan Byrne** is a portrait of Peckham in photography and words at the turn of the Millennium.

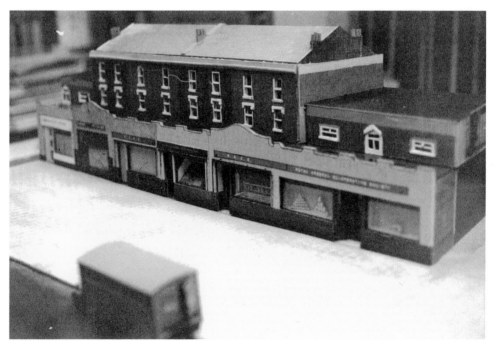

Ray Byfield made this model of a Co-op store.

Dame Elizabeth Cadbury (1858–1951) was born at 3 Elm Place, Peckham Rye. In 1863 her family moved to Sunbury, a large house on the east side of the common. In 1888 Elizabeth married George Cadbury in the Peckham Quaker Meeting House in Hanover Street (now Highshore Road).

Actor **Sir Michael Caine** starred in *Last Orders* (2001). He played the role of a Bermondsey butcher. A former second-hand shop at 194 Bellenden Road was converted into a butcher's shop for the filming. In *The Autobiography The Elephant to Hollywood*, Michael Caine gave a graphic description of his visit to the Tower Cinema in Rye Lane and his experiences with a female member of staff.

Italian **Vangenzi Califano's** ice cream was popular and has been written about by former Peckham residents in *Peckham Society News*.

Prime Minister **David Cameron** had a meeting with a few Peckham residents in a café at 139 Bellenden Road on 17 November 2011.

Architect **Alan Camp** has been responsible for various projects in Peckham and

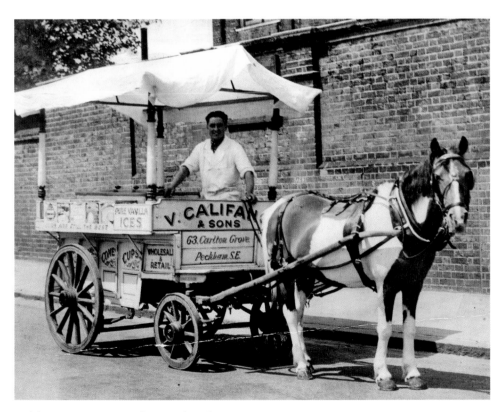

Califano's ice cream is still remembered.

Nunhead including Ashleigh Mews (Oglander Road), 81 Hanover Park, Pioneer House (St Mary's Road) and William Blake House (Elm Grove).

Two sculptures by **Sokari Douglas Camp** are on display in Peckham – outside 81 Hanover Park and at the Pioneer Centre in St Mary's Road.

Christine Camplin, who has been secretary of the Peckham Society since 1989, is writing a book on Peckham and Nunhead schools.

Andrew Carey, son of Archbishop George Carey (q.v.), let his father use his home in Choumert Road for a secret meeting with Camilla Parker Bowles to discuss how she might marry Prince Charles (q.v.)

Founder of Chris Carey's Collections, **Ms Chris Carey**, was born and brought up in Peckham. She built up a £4 million business from scratch.

Archbishop George Carey christened his granddaughter Damara in the Copleston Centre Church in 1999. He was also present at the opening of the Damilola Taylor Centre in 2001 and on the same day presided over a service in memory of Damilola at St Luke's Church.

Author **Arthur Joyce Lionel Cary** (1888–1957) lived at 11 Ivydale Road until he was about eight.

Oswald Chambers (1874–1917) joined Rye Lane Chapel and became a Baptist Minister. He wrote *My Utmost For His Highest*, containing extracts from his lectures and sermons; it was a bestseller.

Dr Samuel Chandler (1693–1766) became minister in 1716 of the Meeting House (built in 1657) in what today is Meeting House Lane. The following year a new meeting house opened at the corner of what today are Rye Lane and Peckham High Street.

Pike Channell (1774–1844), a master mariner who served with Nelson at the Battle of Copenhagen, moved in 1808 to a house in Hill Street. In 1818 he moved to a larger house in Deptford Lane (now Queen's Road) where Cherry Tree Court is today; he died there.

Sir William Fry Channell (1804–73), the first son of Pike Channell (q.v.), became head boy of the Revd Martin Ready's school in the High Street opposite what today is Rye Lane. He later became a judge.

Hannah Chaplin (1865–1928), mother of comedian Charlie Chaplin, was a patient in Peckham House lunatic asylum, which was where the Harris Academy at Peckham is today. Charlie visited his mother there.

Pike Channell died in Peckham.

HRH Prince Charles and the **Duchess of Cornwall** visited All Saints' Church, Blenheim Grove, on 21 July 2010. Prince Charles was interviewed in two *Songs of Praise* broadcasts filmed there.

Yorkshireman **Tim Charlesworth** wrote *The Architecture of Peckham* and *The Story of Burgess Park: From an intriguing past to a bright future.*

Actress **Lorraine Chase** attended Peckham School. When she was a model she supplemented her income by working on Saturdays in Jones & Higgins store in Rye Lane.

Sri Chinmoy (1931–2007) in 1991 opened a Peace Garden named after him in the grounds of the Thomas Calton Education Centre in Alpha Street.

In *Diaries Into Politics: The long-awaited early years* Conservative politician and historian **Alan Clark** (1928–99) recorded on 23 February 1978 that he tracked down a friend's osteopath 'at his block of flats in Peckham' where he received treatment.

Charles Goddard Clarke (1849–1908) was elected MP for the Peckham Division of Camberwell in 1906. He lived in Peckham for forty-two years.

William Cobbett (1763–1835) was a journalist and reformer who became an MP. He stayed with Timothy Brown (q.v.) in Peckham Lodge.

Sir Alan Cobham (1894–1973) attended Talfourd College at 19 Lyndhurst Road (now Way). He was the first British pilot to cross the English Channel in an ultra-light

Winnie Collins painted local scenes.

plane. An English Heritage blue plaque was erected at 78 Denman Road in 2003 to commemorate him.

Jarvis Cocker's band *Pulp* included a song called '59 Lyndhurst Grove' in their 1993 album *Intro: The Gift Recordings*. Jarvis wrote the song after going to a party at that house and was thrown out by the architect owner.

Carpenter **Thomas Coggin** (*c.* 1848–1927) lived at North View, 155 Chadwick Road. A memorial window to him is in the Copleston Centre Church.

Actor **Graham Cole**, who played PC Tony Stamp in *The Bill*, visited Warwick Park School in 1997 to launch a poster campaign aimed at urging people not to carry knives.

Sir Charles Collett (1864–1938) was born in Peckham and was married at All Saints' Church in Blenheim Grove. He was Lord Mayor of the City of London in 1933.

Winnie Collins painted views of Peckham (1925–35) including the Peckham branch of the Grand Surrey Canal.

In the 1730s **Peter Collinson** (1694–1768) had a botanic garden in Peckham that included rare plants. Biographical information about him can be found under Collinson House in *Origin of Place Names in Peckham and Nunhead*.

Dr William Bengo' Collyer (1782–1854) was minister of a chapel which stood at the corner of what today are Rye Lane and Peckham High Street. In 1817 the Dukes of Kent and Sussex attended the opening service after it was rebuilt. It became known as Hanover Chapel.

Actress **Olivia Colman** lives in Peckham and was interviewed in the *Evening Telegraph* on 7 February 2012 after winning the Best Actress award for her performance in *Tyrannosaur*.

Clare Colvin, who lives in Choumert Road, is a novelist and short story writer. Her works include *A Fatal Season* and *Masque of the Gonzagas*.

Colyer was the surname of the person to whom the world's first authenticated stamped letter bearing a Penny Black was sent. It was posted in Bath on 2 May 1840 and sent to Peckham by the daughter of the Postmaster of Bath. The member of the Colyer family to whom the envelope was addressed lived in Union Row in what is now Queen's Road, next to where Cherry Tree Court is today.

Denis Compton (1918–97) played for Nunhead Football Club, Arsenal and England. He was also a Middlesex and England cricketer. More biographical information can be found under Compton Close in *Origin of Place Names in Peckham and Nunhead*.

Expert community activist **Eileen Conn** has lived in Nutbrook Street since 1973. She has initiated and chaired several community organisations including Volunteer Centre Southwark, Southwark Rail Users' Group and Peckham Vision.

Film star **Sean Connery** was a customer at Austin's of Peckham Rye.

Songwriter **Tommie Connor** (1904–93) was inspired by an aspidistra he saw in an Evelina Road house to write a song about the 'biggest aspidistra in the world'.

Radio artiste **Mabel Constanduras** (1880-1957) visited her grandfather, transport pioneer Thomas Tilling (q.v.), at Winchester House in the High Street, Peckham.

Trinidadian cricketer **Learie Constantine** visited the home of Dr Harold Moody (q.v.) at 164 Queen's Road.

Poet **Eliza Cook** (1812–89) lived at 32 Lyndhurst Road (now Way) where many of her best poems were penned.

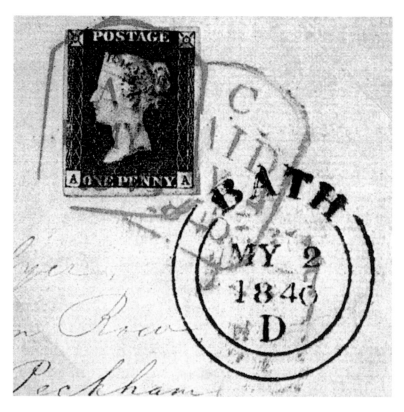

This stamp was sent to Peckham and was the first known posting of any stamp in the world. Bath Postal Museum produced a postcard showing this historic postmark.

Evan Cook (1865–1947) developed his transport business from a second-hand shop at 72 Queen's Road. Additional information can be found in *Origin of Place Names in Peckham and Nunhead* under Evan Cook Close. *See also Peckham and Nunhead Through Time* (page 40).

Peckham Cry was written by **Janice Cooke**. It is an autobiographical account of physical and sexual abuse she suffered as a child in Peckham.

Stage and film actress **Gladys Cooper** (who became a Dame) (1888–1971) opened the Tower Cinema in Rye Lane in 1914.

After her son was shot dead outside a Central London nightclub in 2002, Peckham resident **Lucy Cope** founded Mothers Against Guns.

Chief Justice John Copeland (?1674–1761) died in Peckham. Additional information is included under Copeland Road in *Origin of Place Names in Peckham and Nunhead*.

Freda Corbet (1900–93) was the MP for Peckham from 1945 until 1974.

Golfer **Sir Henry Cotton** (1907–87) lived at 41 Hawkslade Road and attended Ivydale Road School.

Chancellor of the Exchequer **Sir Stafford Cripps** (1889–1952) attended the Odeon theatre in Peckham High Street in 1948 to see *The Centre*, a film about the Peckham Pioneer Health Centre.

Professor Barry Crown, son of Dr Isidore Crown (q.v.), attended Bellenden Road School and became Professor of Law at the National University of Singapore.

Dr Isidore Crown wrote four books about his experiences as a Peckham GP. Isidore Crown Medical Centre in Chadwick Road was officially opened in 1998 by Tessa Jowell, MP, Britain's first Minister of State for Public Health.

George Crutcher ran Hatcham Dairy Farm where Dairy Farm Place is today at 195–201 Queen's Road. He was featured in the *South London Press* on 15 October 1898.

John Brompton Cuming (1772–1851) painted watercolours of Peckham and lived at 7 Hanover Place, Rye Lane (now 26 Rye Lane). His painting of Peckham Rye in 1828, showing the River Peck, is on the cover of *The Story of Peckham and Nunhead*.

The printing firm Cutts & Co., which was based at 113 Bellenden Road, was started by **George Cutts** who died in 1926.

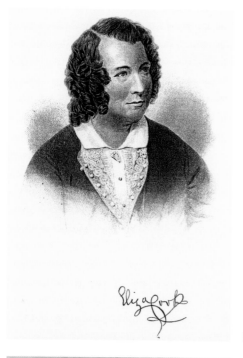

Eliza Cook wrote poems in Peckham.

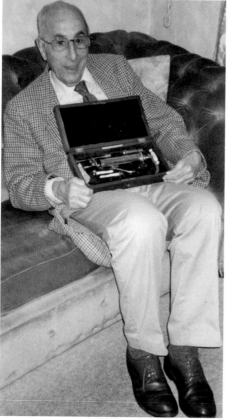

Dr Isidore Crown is holding an old stomach pump given to him by a Peckham resident.

Hugh Dalton (1887–1962) was MP for the Peckham Division of Camberwell (1924–29) and in 1946, when he was Chancellor of the Exchequer, he nationalised the Bank of England. He became a member of the House of Lords.

Todd Dalton of Lyndhurst Way was dubbed the 'Leopard man of Peckham'. He kept leopards and other wild animals in his garden in 2006.

Film producer **John Daly** (1937–2008) lived in Peckham and attended Leo Street School. He was involved in a variety of films that together collected thirteen Oscars, including nine for *The Last Emperor*.

When **Tam Dalyell,** MP (also known as **Sir Thomas Dalyell Loch, 11th Baronet**) visited 6 Everthorpe Road, he watched on television part of *Simon's War*, a programme about the Falklands War and the terrible burns suffered by Simon Weston.

Henry Daniel (1805–67) was the first monumental mason to set up business at Nunhead.

American actress **Bebe Daniels** and her husband **Ben Lyon** opened an event at Jones & Higgins.

Writer **Ann Darnbrough** was the daughter of William Stuttard, a foreign correspondent of *The Times*. As a child she overcame grievous disability caused by spinal tuberculosis. As an adult she has dedicated most of her life to improving the provision of information to disabled people and in recognition was awarded an OBE in 2002. She has lived in Peckham since 1988.

Emma Darwin's novel *The Mathematics of Love* was launched at Review bookshop, 131 Bellenden Road, on 26 July 2006.

Actor **Sam Dastor** lived at 45 Choumert Road (1979–1993).

William Davis (1795–1867) lived in James Place (where New James Court is today). He was a tailor known as Mutton Davis because of his inordinate liking of mutton. While sitting on his tailor's board, he astonished his visitors by making his feet meet at the back of his neck.

Agnes Dawson (1873–1953) was a feminist and head teacher who was born at 121 East Surrey Grove. In 1917 she became headmistress of Crawford Street Infants' School, Camberwell.

Lewis Foreman Day was born at 12 Rye Terrace (now 149 Peckham Rye, SE15). He was a prominent designer whose biographer was Joan Maria Hansen. *Lewis Foreman Day (1845–1910): Unity in design and industry* has 319 pages.

Ann Darnbrough and her husband Derek Kinrade sat as they enjoyed a community event in Bellenden Road.

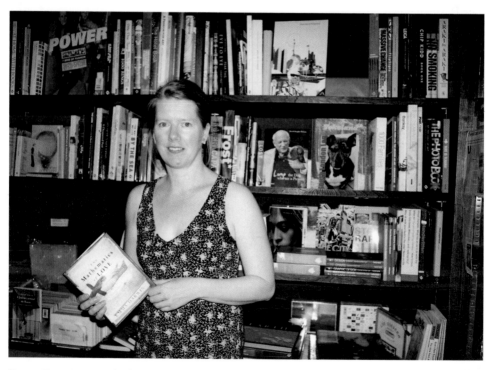

Emma Darwin's novel *The Mathematics of Love* was launched in Review bookshop.

Sam Dastor has had wide
experience as an actor.

Master Butcher **John Dell,** when he was proprietor of W. Head & Co. of 228 Rye Lane,
taught actor Daniel Day-Lewis the art of butchery for his film *Gangs of New York*.

John Denham, MP visited Peckham Library in 2001 and unveiled an ambitious
blueprint for reducing youth crime. He spoke in the Damilola Taylor Centre in 2003
at a conference where the Southwark Strategy on Children and Young People's
Participation was launched.

Sir John Dewrance (1858–1937) was born in Peckham. He was the only son of John
Dewrance who erected the locomotive *Rocket* for George Stephenson. On coming of
age, he took control of the engineering business Dewrance & Co., which had been
left to him by his father. In 1923 he was President of the Institution of Mechanical
Engineers.

Author **Charles Dickens** (1812–70) secretly visited actress Ellen Ternan at her home
– Windsor Lodge, 31 Linden Grove. Peckham is featured in some of his books.

Jonathan Dimbleby chaired *Any Questions?* broadcast on BBC Radio, from the North
Peckham Civic Centre on 1 December 1989.

Charlie Dimmock assisted Peckham residents to improve the McDermott Road Nature Garden (renamed McDermott Grove in 2000 and now McDermott Grove Garden). This was shown in *Charlie's Garden Army* on BBC1 on 7 July 2000. *See* Bob Smyth.

Frank Dobson, MP visited the Peckham Pulse in 1999 when he was Secretary of State for Health.

London merchant **Thomas Dolesley** (died 1370) acquired considerable land in Camberwell parish including the manors of Peckham, Basing and Bretynghurst (the site of Peckham Rye Park).

Lord Donaldson (1907–98) assisted fund raising for new premises for the Peckham Pioneer Health Centre in St Mary's Road. He transferred £10,000 of £22,000 he had inherited from his father to the Centre's account. This generous action inspired other people to give on a larger scale than before.

Poet **John Donne** (1573-1631) visited Peckham quite often after his marriage because his wife's sister was married to Sir Thomas Grymes of Peckham. George, the poet's second son, was born in Peckham.

Film star **Diana Dors** (1931–84) was a customer at the Marks & Spencer store in Rye Lane.

Canon **John Douglas** (1869–1956) became vicar of St Luke's Church in 1909. He left in 1939 and became General Secretary of the Church of England Council for Foreign Relations.

Leonard Dove (1913–2001), who was a member of Peckham Methodist Church, was president of Methodists for World Mission and treasurer of the Methodist Missionary Society.

The **Revd Andrew Augustus Wild Drew** (1837–1921) was vicar of St Antholin's, Nunhead, for forty-eight years.

Charles Henry Driver (1832–1900) was the architect of Peckham Rye Station.

Victorian Suburb: A Study of the Growth of Camberwell by **H. J. Dyos** includes important information on Peckham's history published in 1961.

Teresa Early founded the New Peckham Varieties in 1983 to provide after-school drama and dance training for children in the Peckham area.

Astronomer **Sir Arthur Stanley Eddington** (1882–1944) attended the Quaker Meeting House in Hanover Street (now Highshore Road) when he was chief assistant at the Greenwich Observatory (1906–13).

James Chuter Ede, MP, who became **Lord Chuter-Ede** (1882–1965), opened the Kirkwood Training Centre for Civil Defence, at a corner of Kirkwood Road and Brayards Road, on 9 October 1954.

HRH the Duke of Edinburgh visited the Bradfield Club, Commercial Way, in 1952. He next visited in May 1985 when he opened the newly refitted building.

James Edwards wrote *A Companion from London to Brighthelmston* (1801), which gave a detailed description of the route from the capital to what is now Brighton. He gave an account of buildings in the High Street and some other roads in Peckham.

Editor and philanthropist **John Passmore Edwards** (1823–1911) donated Nunhead Library and laid the foundation stone on 11 April 1896. He and his wife attended the opening on 1 December 1896. He donated a drinking fountain to Leyton Square Public Garden and was present at the opening ceremony on 26 June 1901.

Actor **Pat Egan**, father of Patrick Beresford Egan, played a leading role in the Christmas 1907 pantomime *Jack and the Beanstalk* at the Crown Theatre in the High Street (where Gaumont House is today).

Racing driver **Victor Henry Elford** was born in Peckham and lived at 75 Peckham Hill Street from *c.* 1940 to *c.* 1954.

HM Queen Elizabeth the Queen Mother (1900–2002) attended the opening of St Mary Magdalene Church, St Mary's Road, on 3 November 1962.

Pam Elven, who was a member of the Pioneer Health Centre in St Mary's Road, unveiled a plaque there in 2005 to celebrate the 70th anniversary of its opening. *See Peckham and Nunhead Through Time* (page 37). Mrs Elven is now the President of the Pioneer Health Foundation which promotes the history and values of the highly acclaimed health centre.

Emburey is the autobiography of former Middlesex and England cricketer **John Emburey** who was born at 11 Meeting House Lane.

Artist **Tracey Emin** lived in Peckham for twelve years.

Boxer **Chris Eubank** moved to Peckham when he was eleven. He attended Bellenden Junior School, Thomas Calton School and Peckham Manor School (from which he was expelled after only one month).

Bernard Evan-Cook (1922–2011) ran the transport firm in Queen's Road started by his grandfather Evan Cook (q.v.) He was also a Director of the Peckham and Kent Road Pension Society founded in 1834.

Arthur Edgar Caswallon Evans was born at 25 Pitt Street and worked for the engineering firm Dewrance & Co for over fifty years. He received the BEM in 1946 'for the interest he maintained in making the burdens of others lighter'. On the remains of the Tower Cinema in Rye Lane is a verse written by Caswallon Evans.

Actress **Monica Evans** was a pupil at Peckham School and appeared in *Compact* on television.

John Evelyn (1620–1706) visited Peckham on 12 June 1676 and wrote in his diary: 'I went to Sir Thomas Bond's new and fine house by Peckham; it is on a flat, but has a fine garden and prospect through the meadows to London.' He visited again on 23 September 1681.

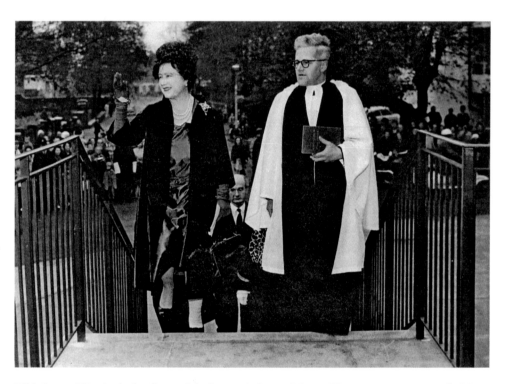

HM Queen Elizabeth the Queen Mother and Canon Victor King prepare to enter St Mary Magdalene Church for its consecration.

Actor **Kenneth Farrington** lived at 88 Lyndhurst Way and attended Lyndhurst Grove Primary School.

Richard Farris (1832–78) lived at 43 Stanton Road. He is commemorated in Postman's Park, Aldersgate, where people who died in heroic circumstances are honoured. One plaque states: 'Richard Farris, labourer, was drowned in attempting to save a poor girl who had thrown herself into the Canal at Globe Bridge, Peckham, May 20 1878.'

Broadcaster and jazz singer **Jumoke Fashola** lives in Peckham. Referring to Rye Lane she stated: 'The diversity you get in those shops is amazing.'

Premier League footballers **Rio** and **Anton Ferdinand** were brought up at 18 Gisburn House on the Friary Estate.

Vincent Figgins (*c.* 1767–1844), who helped to create a revolution in typographical styles, had his country residence at 1 Prospect Place, Peckham Rye. He died there.

Harold and **Walter Finch** were born in Burchell Road. *Origin of Place Names in Peckham and Nunhead* was dedicated to them and their wives. Additional information is in the author's preface and under Finch Mews.

June Fisher (1929–95), who taught at Peckham School, was President of the National Union of Teachers (1989–90).

In *And The Road Rests* **Kathleen Taylor FitzPatrick** (b. 1905) wrote about her childhood in Nunhead.

Sculptor **Mark Folds** invented the 'I love Peckham' slogan.

Artist **William Keddie Forrester** (1914–59) lived at 132A Copleston Road. A memorial exhibition of his work was held at the South London Art Gallery in 1961. Among his works was *Ruins of Winchester House, Peckham High Street*, painted in 1952.

William and **Gilbert Foyle** ran a bookshop in Station Parade, Queen's Road. They transferred to Charing Cross Road where Foyles bookshop became famous.

TV cook **Silvana Franco** works in Choumert Mews. She is an author of cookery books.

The Times reported that **Simon Freakley**, partner of corporate undertakers Buchler Phillips, lived in Peckham for twelve years. Two weeks after moving to South Kensington his Mercedes, which had survived unmolested in Peckham, was stolen.

Dental Surgeon **Peter Frost** has been chairman of the Peckham Society since 1990. He was President of the British Society of Gerodontology in 1998.

RIO **FERDINAND**

A blue plaque on the Friary Estate pays tribute to this brilliant footballer.

Microbiologist Walter Finch
was chair of governors of
Waverley School.

Pamela Elven and Peter Frost
were photographed at 142
Queen's Road after
Dr Frost had unveiled a plaque
commemorating
Dr Innes Pearse and
Dr George Scott Williamson
who started The Pioneer
Health Centre there in 1926.

Balloonist **George Burcher Gale** (1794–1850) made his first ascent with success in 1847 from the grounds of the Rosemary Branch tavern (at the corner of what are now Southampton Way and Commercial Way). Biographical information about George Burcher Gale can be found under Burcher Gale Grove in *Origin of Place Names in Peckham and Nunhead*.

Louis Gandolfi (1864–1932) and his sons Thomas, Fred and Arthur were makers of hand-made wooden cameras in Peckham and Nunhead. The centenary of the Gandolfi enterprise was marked by a special exhibition in the Science Museum in 1980. Additional information is included under Gandolfi Street in *Origin of Place Names in Peckham and Nunhead*.

Sir Thomas Gardiner (?–1632), who was a Justice of the Peace for Surrey, lived at Basing Manor House in the High Street. King Charles I visited him there.

West Indian cricketer **Joel Garner** visited the Montpelier pub in Queen's Road on several occasions.

Gautrey Road is named after **Thomas Gautrey**. A potted biography of him is included in *Origin of Place Names in Peckham and Nunhead* under Gautrey Road.

Actress **Lisa Geoghan**, who played Polly in *The Bill*, visited the Aylesham Centre in 1993 to turn on the Christmas lights.

Gibbon Road commemorates **Charles Gibbon** (1843–90) who was the first editor of the *South London Press*. For many years he lived in South Grove (now Holly Grove). He was also included in *Origin of Place Names in Peckham and Nunhead* under Gibbon Road.

Actress **Llewella Gideon**, who was brought up in Peckham, played in *Porkpie* – the comedy follow-up to *Desmond's*.

Dr Edward Theodore Gilbert was a medical doctor who lived and practised at 4 Queen's Road. He had a distinguished military career with the Royal Army Medical Corps and was awarded an OBE and a DSO.

Century in my Pocket is the autobiography of **John Gilbert** (b. 1902) who lived at 1 Adys Road when he was a child. The book includes a photograph of the yard at the rear where his family kept cows in winter.

George Gill (1922–2010), who was born on the island of St Lucia in the West Indies, made the plaque to celebrate the first sermon broadcast by radio in Britain in 1922. It was broadcast from Blackheath by Dr James Ebenezer Boon (q.v.) to his congregation at Christ Church, McDermott Road.

George Gill made the plaque commemorating an historic sermon.

Trudie Goodwin had an allotment where people now live.

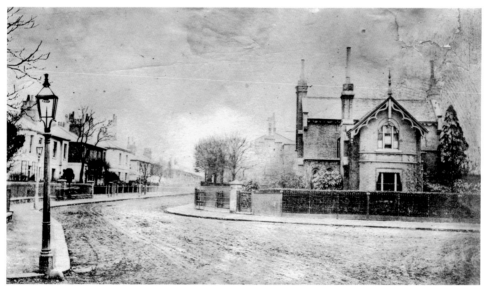

William Griggs photographed Elm House.

When Norma Gibbes was head of Warwick Park School, **HRH the Duchess of Gloucester** visited on 6 May 1993 to open a technology block.

Poet and playwright **Oliver Goldsmith** (1728–74) was an usher (assistant teacher) in Dr Milner's Academy in Peckham. Additional information can be found in *Origin of Place Names in Peckham and Nunhead* under Goldsmith Road.

Victor Goodman found a 5,000-year-old polished flint axe head on the Clifton Estate. More information is included in *Peckham and Nunhead Through Time* (page 46).

Actress **Trudie Goodwin** played Sergeant June Ackland in *The Bill*. She lived in Choumert Road and had an allotment in McDermott Road before houses were built there between Maxted Road and Reedham Street.

Sculptor **Antony Gormley** had a workshop in Bellenden Road, close to which are the unusual bollards he designed.

Luke and **Matt Goss** were members of a band called 'Bros' who lived at 314 Commercial Way. It became a Mecca for thousands of fans in 1988.

Cricketer **W. G. Grace** (1848–1915) used bats made by George Bussey (q.v.). In *Some memories of old South London* Mabel August recorded meeting W. G. Grace several times in Chadwick Road.

In the 1970s actor **Charles Gray** (1928–2000) played an impoverished peer in *The Upper Crust* series on BBC television, some of which was filmed inside number 4 Everthorpe Road.

Artist **Ed Gray** was a teacher at St Thomas the Apostle College in 2004 when he had an exhibition at Camberwell's Great Expectations gallery.

On the day Peckham Rye Park opened, Whit Monday (14 May) 1894, **Dr William Thomas Greene** of 186 Peckham Rye was presented with a special certificate 'To offer you our very sincere congratulations upon the completion of your labours and the success of your efforts to secure an additional recreation ground for the inhabitants of South London.' It is preserved in Southwark Local History Library.

Actress **Jaye Griffiths** visited Peckham police station in 1993 to research her role in *The Bill*.

William Griggs (1832–1911) was a pioneer of photolithography who developed a method of printing in colour by first transferring a faint impression on the paper to serve as a 'key', separating the colours on duplicate negatives by varnishes, then carrying out the photolithography process on each portion on a stone, and finally

registering and printing each in position. From 1868 he produced many beautiful examples of colour photolithography at his Peckham works, culminating in the plates for Warner's *Illustrated Manuscripts in the British Museum*. His home was Elm House, Elm Grove (which still exists on the corner of Elm Grove and Highshore Road) and his factory was where 27, 27a and 27b Highshore Road are today.

Grummant Road commemorates **John Grummant** (1819–99) who lived at 1 Lawn Houses, Peckham Road. This was a large house on the north side of Peckham Road opposite where Peckham Lodge is today.

There is a local legend that **Nell Gwyn** (1650–87) played in the theatre in the High Street though no proof has been found. However, a comedy in three acts was published in 1799 called *The Peckham Frolic or Nell Gwyn*. Charles II is believed to have been a frequent visitor at the home of Sir Thomas Bond (q.v.) so it is not beyond the bounds of possibility that the King saw Nell Gwyn perform at Peckham Theatre.

Lord Harris of Peckham was brought up in SE15.

Dr Thomas Hadfield was a medical doctor who became a Congregational Minister and spent his whole ministry at Hanover Chapel from 1726 until he died in 1741.

Solicitor **Ralph Haeems** (1940–2005) set up in practice at 9 Blenheim Grove in 1977. He acted for some of London's most notorious criminals including the serial killer Dennis Nilsen and the Kray twins. In his obituary on 19 April 2005 the *Guardian* wrote that there was hardly a South London criminal worthy of the name who had not beaten a path to his offices in Peckham.

Publisher, editor and literary agent **James Hale** (1946–2003) lived in a house overlooking Peckham Rye.

Band leader **Henry Hall** (1898–1989) was born at 22 Bonar Road. He played in the Nunhead Salvation Army band.

Alfred Harman (1841–1913) ran a photographic shop in the High Street and became the founder of Ilford Ltd. The story is told in *Silver by the Ton – a History of Ilford Limited 1879–1979*.

Footballer **David Harper** was born in Peckham. He played for Millwall in 190 games (1957–65).

Lord Harris of Peckham was born in St Albans but was brought up in Blakes Road. After leaving school at the age of fifteen he worked in Rye Lane Market for the next five years.

Sir John H. Harris (1874–1940) was a member of the Peckham Quaker Meeting House. Biographical information about him is included in *Origin of Place Names in Peckham and Nunhead* under John Harris House.

Cyclist **Reg Harris** (1920–92), who won two silver medals at the 1948 Olympic Games, was a special customer at the cycle shop in Queen's Road owned by Reginald Harrison (q.v.).

Reginald Oliver Harrison, who was a member of the Institute of Mechanical Engineers, made bicycles in a shop at 41–43 Queen's Road. They were known as New Star Cycles.

Sgt Jack Harvey, VC (1891–1940) was born in Peckham. He joined the army in 1914 and saw all his service on the Western Front. He was awarded a VC.

Hayes Grove in SE22 commemorates Surrey cricketer **Ernest George Hayes** (1876–1953) who was born in Peckham.

Philanthropist **Isaac Heaton** (died 1810) lived in a mansion in Rye Lane called Peckham Lodge, close to where Hanover Park is today. On the very extensive lawn in the south east was Heaton's or Eton's Folly. This was built by about 500 men during a very severe winter in order to provide them with work.

Footballer **Ronald Heckman** was born in Peckham and played for Millwall (1957–60).

100 Years of Progress (published by H. J. Heinz Co. Ltd in 1986) includes a photograph of **Howard Heinz** with his Peckham factory staff in June 1922.

Albert Edward Heming was awarded the George Cross for heroic work in rescuing Father Arbuthnot who was trapped under the debris of the Dockhead (Bermondsey) Church, which was demolished by an enemy long-range *V2* rocket on 2 March 1945 during the Second World War. He died in Peckham in 1987.

Actor **David Hemmings** (1941–2003) played in *Blow-Up*, in which he was seen coming out of Camberwell Reception Centre. From Consort Road he went into Copeland Road where he got into a car and drove off.

John Frederick Herring (1795–1865) was born in the vicinity of Lord's Lane (now Peckham Hill Street). He was a coachman who became an artist and for many years he painted the winner of the Doncaster Races.

When singer/songwriter **Helen J. Hicks** was interviewed by the *South London Press* (18 May 2007), she was asked about living in Peckham. She said, 'It reminds me of Notting Hill ten years ago. There's edgy bits and leafy bits so you almost feel like you're in the country yet you're ten minutes away by train from central London. I absolutely love it.'

The **Revd Harold Higginbotham**, who had been a curate at St Antholin's, Nunhead, became Archdeacon of Rangoon. He was killed in 1943 in Burma by a Japanese officer's sword while championing women and children whom the Japanese were ill-treating.

George Randell Higgins (1844–1920) was the co-founder of Jones & Higgins. In 1867 he and his former fellow apprentice Edwin Jones (q.v.) opened their shop at the corner of what today are Rye Lane and Peckham High Street.

Peckham Hill Street, originally Lord's Lane and later Hill Street, was named after **Martha Hill**. In 1732 she bought Peckham Manor House and estate after the death of Lord Trevor (q.v.).

Maria Hinckesman (1803 –?) lived in Union Row, Peckham, when she produced her musical compositions *A rose-bud* (1823) and *Ye tell me shepherds* (1824). Both songs were dedicated to Peckham residents – the latter to Peckham surgeon Josiah Henry Wilkinson (q.v.).

Tony Hinnigan, when he was a Bellenden Road resident, wrote the music for a special service televised live from Coventry Cathedral on Christmas Eve 1988. Music was played by the composer and other members of Incantation.

Actor **Ram John Holder** played Porkpie in *Desmond's*, a popular sit-com based in a barber's shop at 204 Bellenden Road.

Writer and bookseller **William Hone** (1780–1842) moved in 1833 to Rose Cottage, Peckham Rye. Water from his well was used for making tea in the summer for Sunday School treats on the common.

Boxer **Lloyd Honeyghan** went to Warwick Park School on 25 September 1987 to launch an anti-knives campaign. He said that the problem had not existed when he was growing up in Peckham.

Writer and editor of *Fun* **Tom Hood** (1835–74) lived at Peckham Rye overlooking Rye Lake. He died at Gloucestershire Cottage, Peckham Rye.

Artist **Duncan Hoosan**, with children from Oliver Goldsmith School, designed four eye-catching globes outside Peckham Library. Each represents one of the four elements – earth, air, fire and water – and their coming together in Peckham.

Defrocked Nunhead Roman Catholic priest **Neil Horan** ran on the track during the Silverstone Grand Prix in 2003 and disrupted the finish of the Athens Olympic Marathon in 2004.

The 2nd and last **Lord Horder** visited Christopher and Marjorie Idle (q.v.) in their home at 13 Unwin Close. He composed several tunes for hymns written by the Revd Christopher Idle.

Actor **Bob Hoskins** was seen in Everthorpe Road and Oxenford Street in 2000 when he was filming *Last Orders*, which included Sir Michael Caine (q.v.). *See Peckham and Nunhead Through Time*, page 66.

Mabel Strangeways Hounsell (?–1927) worked as a housekeeper to Dr William Charles Jarvis whose home and practice were at 325 Southampton Street (now Way). She founded Sister Mabel's Free Dispensary for Sick Animals of the Poor of South London. More information is included in *Origin of Place Names in Peckham and Nunhead* under Sister Mabel's Way.

Baroness Howe of Idlicote lives in Peckham and has been President of the Peckham Settlement since 1976.

Television broadcaster **Kate Humble** opened the waste and recycling facility in the Old Kent Road in April 2012.

The most knowledgeable person on the history of the London Borough of Southwark, **Stephen Humphrey,** wrote *Britain in Old Photographs: Camberwell, Dulwich & Peckham*. He has also written articles on Peckham as a *South London Press* columnist.

England World Cup legend **Sir Geoff Hurst** joined youngsters and adults on Peckham Rye Common on 22 August 2009 for a day of football.

John Hutton, MP, Minister of State for Health, visited Peckham Pulse in February 2005. He was impressed by the Southwark exercise referral service.

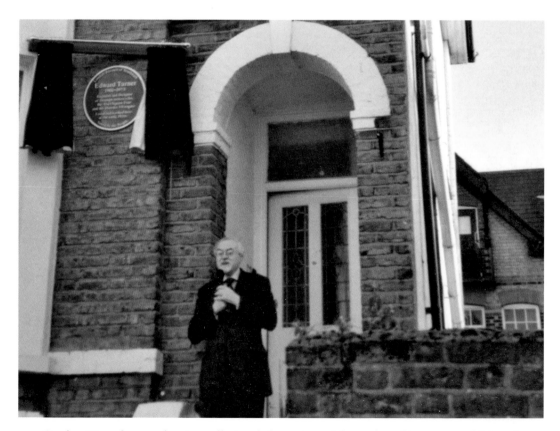

Stephen Humphrey spoke at a well attended event to celebrate the achievements of Edward Turner.

The **Revd Christopher M. Idle** and his wife **Marjorie** lived at 13 Unwin Close (1995–2003). Christopher is a prolific writer. He was curate of Christ Church, Old Kent Road (1968–71). Marjorie was the author of *Joy in the City* and *Living with Bereavement*. Many of the hymns in *Light upon the River* were written by Christopher when he was living in Peckham.

Actor **Jeremy Irons** worked at St Luke's Church in 1966 and ran the youth club. He played his guitar at some services. He lived at 37A Talfourd Road. In an interview in the *South London Press* (15 March 1996) he said, 'I had a great year of my life in Peckham.'

Canon Don Irving (1931–2006) was born in Peckham. Through his involvement with St Mary Magdalene's Church he became a clergyman.

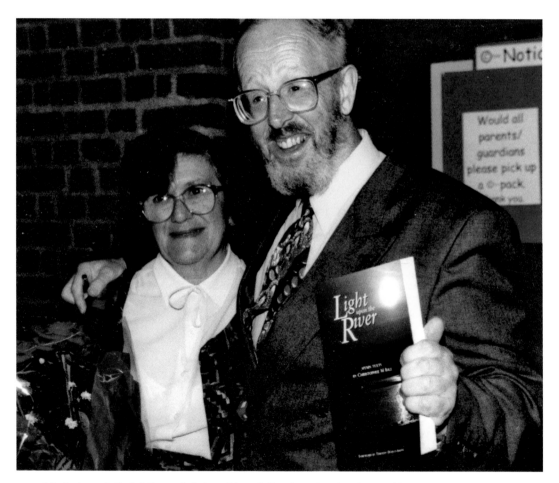

Marjorie and Chris Idle used their writing skills when they lived in Peckham.

Ahmed Sheriff Jalloh, who was born in Sierra Leone and moved to Peckham in 1991, carried the Olympic Flame through Southwark on 26 July 2012 in recognition for coaching youth football and encouraging young people to stay away from crime and continue with their education.

Trinidadian historian and novelist **C. L. R. James** visited the home of Dr Harold Moody (q.v.) at 164 Queen's Road.

Actress **Marianne Jean-Baptiste** grew up on the North Peckham Estate. She was the first British black actress to be nominated for an Oscar.

Clive Jermain (1965–88) suffered pain and disability as a child when he lived at 54 St Mary's Road. He was a presenter for a programme for disabled people called *One in Four*. He became a public figure by writing the play *The Best Years of Your Life* shown on BBC television.

Journalist and author **William Blanchard Jerrold** (1826–84) lived in Lyndhurst Square. He became editor of *Lloyd's Weekly London News* in 1857.

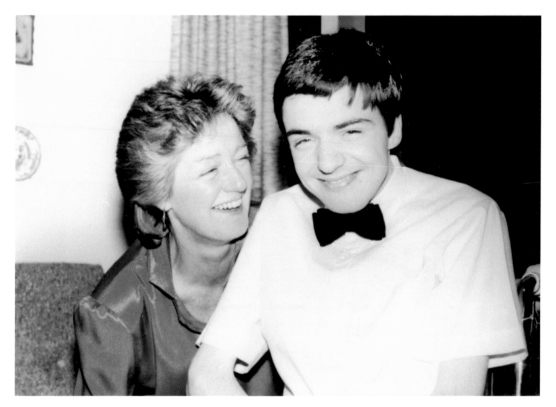

Clive Jermain's mother was happy to be with her talented son.

From this small shop grew a large department store.

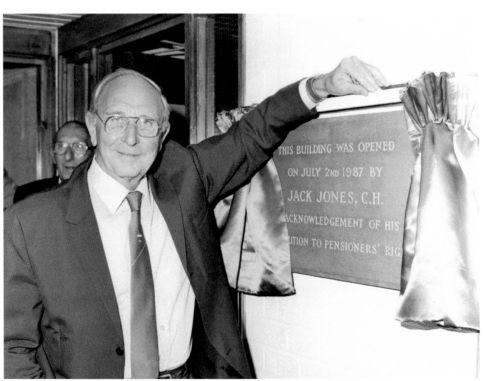

Jack Jones opened residential accommodation for pensioners in Reedham Street.

There is a tradition that **King John** (1167–1216) killed a stag while hunting at Peckham and was so pleased with the sport that he granted a fair of three weeks' duration. Unfortunately no charter has been found.

Bob Johnson failed his A-levels and began work in the Peckham branch of his father's company. He became the founder and chairman of the £200 million turnover mail-order retailer Farepak PLC (subsequently called Kleeneze).

The European Under 23 Long Jump champion **Jade Johnson** went to Warwick Park School in July 2001 to share tips and advice with pupils.

Edwin Jones (1837–1916) was the co-founder of Peckham's best known former store Jones & Higgins. He and George Randell Higgins (q.v.) became apprentices to an old established business for £12 a year. By 1867 the two young men had saved enough money to open a small draper's shop at No. 1 Coburn Terrace, later known as No. 3 Rye Lane.

Former general secretary of the Transport & General Workers' Union, **Jack Jones** (1913–2009), celebrated his ninetieth birthday in Jack Jones House, Reedham Street, which he had opened in 1987. *See* Jack Jones House in *Origin of Place Names in Peckham and Nunhead.*

In 1868 **Samuel Jones** (1818–80) purchased 67 and 69 Peckham Grove and erected a small factory at the bottom of the garden at number 67. A large gummed paper factory was later built on the site.

Mabel Jordan was three years old when she moved to Haymerle Road. *Mabel Jordan: An Autobiography* includes information about treatment she received from Dr Alfred Salter (q.v.) and being a pupil at Reddin's Road School, which was also attended by Johnny Trunley (q.v.) and Edgar Wallace (q.v.).

London's last cow keeper was **John Jorden** who kept a herd of cows in Lugard Road until 1967.

Tessa Jowell, MP, who became a Dame in 2012, and **Harriet Harman**, MP, officially opened Peckham Square on 29 September 1994.

Two local Members of Parliament, Tessa Jowell and Harriet Harman, performed the Peckham Square opening ceremony.

Michael Keating played Vila in *Blake's 7* on BBC television.

Swedish traveller **Peter Kalm** wrote about his visit to Peckham. In *Kalm's account of his visit to England on his way to America in 1748* (published by Macmillan in 1892) there is a description of his visit to Peter Collinson's (q.v.) garden in Peckham on 10 June 1748. It begins:

> In the afternoon I went out to Peckham, a pretty village which lies three miles from London, in Surrey, where Mr. Peter Collinson has a beautiful little garden, full of all kinds of the rarest plants, especially American ones which can endure the English climate, and stand out the whole winter. However neat and small this garden was, nevertheless, scarcely a garden in England in which there were so many kinds of trees and plants, especially of the rarest, as in this. It was here that Mr. Collinson sometimes, as often as he got time from his business, amused himself in planting and arranging his living collection of plants.

Actor **Michael Keating**, who plays the vicar in *EastEnders*, lives in Everthorpe Road.

Sally Keeble, MP, a former Leader of Southwark Council, on 20 September 2001 officially opened new housing on the site of the former steam bus garage in Nunhead Lane.

Novelist **Mary Ann Kelty** (1789–1873) lived at 5 Hanover Street (now 10 Highshore Road) where she wrote many books including *Memoirs of the Lives and Persecutions of Primitive Quakers*.

Jomo Kenyatta, who became the founding President of Kenya, visited the home of Dr Harold Moody (q.v.) at 164 Queen's Road.

Southwark's first black Mayor **Sam King** was born in Jamaica. He became a Councillor for Bellenden Ward in Peckham in 1982. The following year he was elected as Mayor. His autobiography is *Climbing up the Rough Side of the Mountain*.

Chimney sweep **Thomas Kingsbury** became a Christian preacher and spoke on Peckham Rye Common for about forty years. He ran Peckham Rye Mission Church in what today is Dewar Street.

In his Highshore Road home, where he has lived since 1988, **Derek Kinrade** wrote a 500-page biography of Lord Morris of Manchester, *Alf Morris People's Parliamentarian*. Derek Kinrade was made a Companion of the Imperial Service Order in 1992 for services to the Office of Fair Trading.

The front page lead story in the *South London Observer* on 8 October 1937 was about a 'missing' heir to one of the oldest baronetcies in the United Kingdom – **Charles Bartram Kirkpatrick**. He was living in Manor Grove and had been born in Asylum Road and was then sixty-four years old.

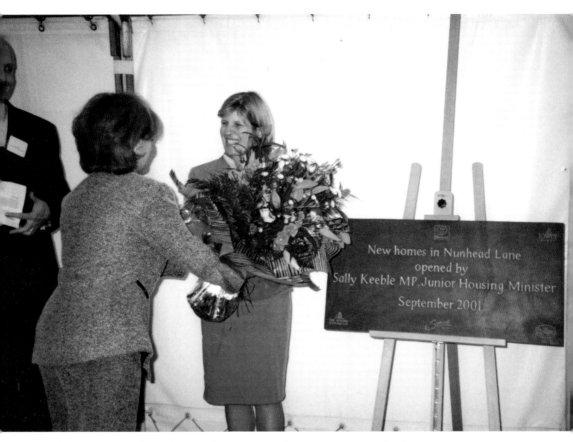

Sally Keeble opened new homes where a garage for steam buses was built in 1911.

Houses in the High Street, Peckham, were painted by **Charles Kirshaw** in 1830. The original painting is in Perth, Western Australia, where it is owned by John Doddemeade who gave the Peckham Society permission to publish postcards showing the view on page 57.

David Kitchen (1942–2005) was an outstanding director of the Peckham Settlement from 1997 until 2004.

Artist **Randy Klein,** who lives in Nunhead, designed 'The Tiara' entrance to Brimmington Park and has brightened up other parts of SE15. Photographs of his other works are included in his book *Road*.

Author **Flora Klickman** (1867–1958) lived at 82 Ondine Road. She wrote books about Flower-Patch Cottage and edited *Girls' Own Paper*. Later owners of her house were George and Grace Smith-Grogan whose experiences in SE15 and SE22 are included in *Peckham and Nunhead Remembered* and *East Dulwich Remembered*.

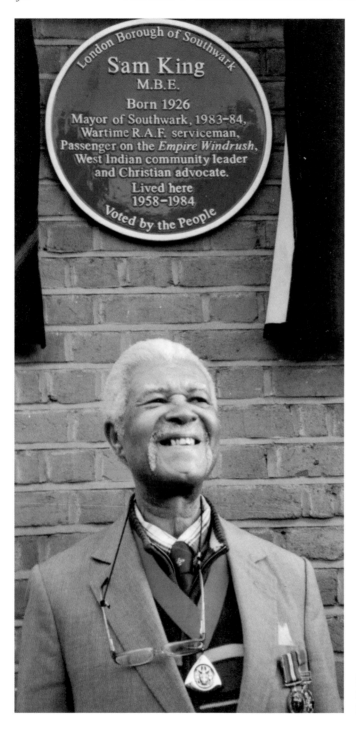

Sam King is highly regarded in the London Borough of Southwark.

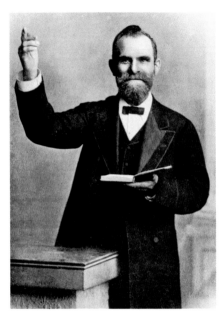

After nearly 35 years Thomas Kingsbury relinquished oversight of Peckham Rye Mission Church.

Nearly 200 years ago Charles Kirshaw painted part of the High Street, Peckham. Number 58 Peckham High Street is now a Grade II listed building.

Harry Lamborn, MP (1915–82) was born in the Old Kent Road and was MP for Peckham from 1974 until his death.

James Laming, a car dealer and inventor from Peckham, made a horse stun gun, which he used at Ascot in 1988 to throw the racehorse Ile de Chypre and the jockey who were within a furlong of the winning post at the King George V Handicap.

Culture Minister **David Lammy**, MP went to Peckham Library on 21 July 2005 for the launch of a scheme to encourage children and young people to read at least six books of their choice during the summer holidays.

Alan Lancaster, who became the bass guitar player for Status Quo, grew up in Rosemary Road.

Mary Langman (1908–2004) was secretary to Dr George Scott Williamson (q.v.), co-founder of the Peckham Pioneer Health Centre. She was one of the founder members of the Soil Association.

Artist **John Latham** (1921–2006) lived and worked at Flat Time Ho, 210 Bellenden Road. He created a relief of an exploding book which was installed in the front window of his studio.

The first Capuchin to arrive in England was an Italian friar called **Luigi di Lavagna**. He came to learn the language and acted as a chaplain to a sisterhood in Peckham.

Glover House resident **Naomi Leake** wrote *From Peckham to Paradise*. This book was written in English and Welsh; it won an award for the best bi-lingual design in 2006.

Thirteen-year-old **Isaac Lee-Baker**, who grew up in Peckham, played a soldier in *The Nutcracker* staged in Covent Garden on 17 December 2005 to an audience of almost 2,500 people.

Robert James Lees (1849–1931) founded The People's League in the Central Hall, High Street, in 1893. In 1891 he lived at 67 Ondine Road.

An exhibition of **John Lessore's** London paintings was held at the Berkeley Square Gallery in 2002. The catalogue included eight Peckham scenes.

Singer and song writer **C. J. Lewis** was born at 41 Cheltenham Road and later lived at 185 Bellenden Road. He attended Ivydale Road School. He was a youth worker at the Claudia Jones Project in Bellenden Old School.

Artist **Charles James Lewis** (1830–92) lived at Nelson Square in 1854. He is included in the *Oxford Dictionary of National Biography*.

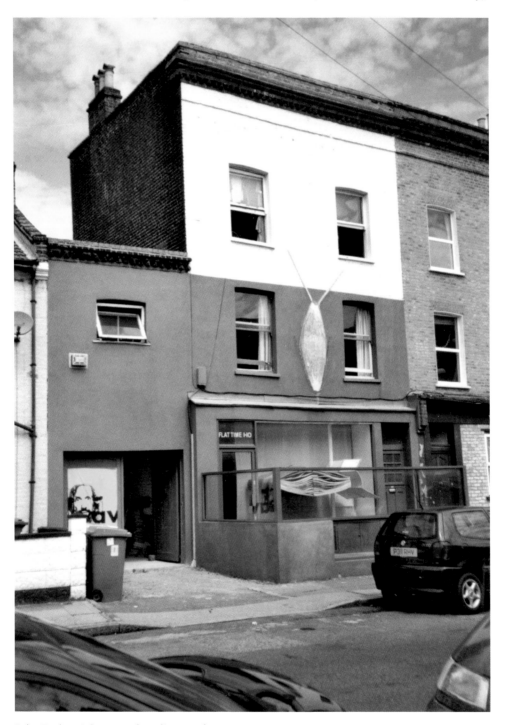

John Latham's home and studio were here.

German actor **Edward Lieven** went to the Odeon cinema, Peckham High Street, in 1947 when *Frieda* was shown. In the film he played a diehard Nazi. This was his first public appearance on the stage of any cinema.

The **Revd Edmund Lilley** (1807–94) founded the Peckham and Kent Road Pension Society in 1834 when he was minister at Peckham Chapel in Hill Street. In 2012 the chairman is Jeff Burnige, a former chairman of Millwall Football Club.

'Secret Millionaire' IT tycoon **Dominic List** went to Peckham in 2009 for the Channel 4 programme *Secret Millionaire*. He gave away tens of thousands of pounds to help individual people and projects in Peckham.

Sir George Livesey (1834–1908), whose statue is in the grounds of the former Livesey Museum in the Old Kent Road, worked for the South Metropolitan Gas Company. He became chairman of the board of directors in 1885. He was well-known for his Co-Partnership Scheme of profit sharing from 1889.

In 1898 music-hall artiste **Marie Lloyd** (1870–1922) played the title role in *Dick Whittington* at the Crown Theatre in the High Street (where Gaumont House is today).

C. J. Lewis (right) attended the opening of the Peckham Premier cinema, Rye Lane, on 7 October 1994.

Spy **Gordon Lonsdale** (1924–70) was partner in the Peckham Automatic Co. Ltd which operated ball gum machines. He worked from above a shop at 163 Rye Lane from 1957 for about two years. His office was in the same rooms which had been used by Tommy Steele (q.v.).

Lord Loughborough, who began his career with the Metropolitan Police in 1980, started patrolling the streets of Peckham.

Eminent antiquary **Mark Anthony Lower** (1813–76) lived in Montpelier Road off Queen's Road. He was the author of a number of books including *Patronymica Britannica – A Dictionary of Family Names of the United Kingdom.*

The **Revd Daniel Lysons,** Chaplain to the Right Hon. The Earl of Orford, wrote about Peckham in *The Environs of London: Being an historical account of the Towns, Villages, and Hamlets, Within Twelve Miles of that Capital; interspersed with biographical anecdotes.* It was published in 1792. This included Samuel Chandler (q.v.) and Lord Trevor (q.v.).

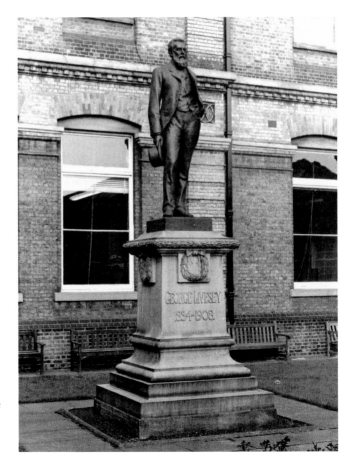

Attempts are being made to persuade Southwark Council to move Sir George Livesey's statue to a site close to the railway station in Queen's Road.

Wally Macfarlane (*c.* 1911–97) moved to the London County Council's newly built Rye Hill Estate in 1938. He wrote *The Scottish Martyrs: The Story of the Political Reformers 1793–4* published by the Friends of Nunhead Cemetery.

A former Peckham underworld criminal **Johnny Mack** had his third book published in 2012 – *Memoirs of a Hitman*.

Founder of the Iona Community, **George MacLeod**, visited the Peckham Pioneer Health Centre in 1948.

Prime Minister **Harold Macmillan** (1894–1986), who became the first Earl of Stockton, addressed a crowd gathered around the disused air-raid shelter on Peckham Rye in 1959 during the General Election campaign.

The *South London Press* on 4 September 2009 reported that **Madonna** had shot videos in Peckham.

The Pearly King of Peckham **George Major** has written the first volume of his autobiography *The Hidden Whistle And Flute: Stitch One*.

Dame Norma Major was a pupil at Peckham School (where the Harris Academy at Peckham is today). She became Head Girl.

Boxing manager **Frank Maloney's** autobiography is titled *No Baloney*. He lived at 56 Talfourd Road, in a house which belonged to St James the Great Catholic Church in Elm Grove.

Professor Sir Peter Mansfield attended Peckham Central School and then William Penn School, Choumert Road. He was told that science wasn't for him and had to leave school when he was fifteen. He became a physicist and was awarded the Nobel Prize for Medicine in 2003.

HRH Princess Margaret (1930–2002) opened flats for elderly people in Troy Town on 21 October 1952. She performed the official opening ceremony at the Aylesham Centre on 21 July 1988. She also made visits to the Peckham Settlement as she was the charity's patron for over fifty years.

William Margrie (1878–1960) was a prolific writer who founded the London Explorers Club. He attended Gloucester Road School and died at 24 Nigel Road.

Songwriter **Bob Marley**, before he became a famous reggae star, visited the Cator Street site of Peckham Manor School in 1972. Photographs of the visit were published in *Southwark News* on 4 November 2010.

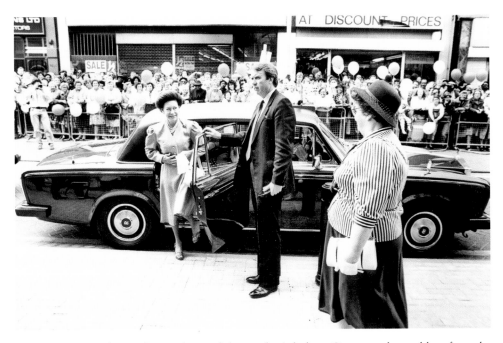

Princess Margaret leaves the car that took her to the Aylesham Centre so she could perform the opening ceremony some time after the Centre opened for trading.

Local historian **Walter William (Bill) Marshall** (1928–2007) lived at 9 Highshore Road and then 10 Cardine Mews. When he was Peckham Town Manager he edited *The Peckham Development Handbook*. He was a member of the Peckham Town Band.

Jamaican poet **Una Marson** came to Britain in 1932 and lived with the Moody family at 164 Queen's Road. She became a BBC broadcaster. Delia Jarrett-Macauley wrote *The Life of Una Marson (1905–65)*.

HM Queen Mary (1867–1953) visited St Luke's Church in 1892 (when she was a Princess), 1926 and 1927. She also visited Pitt Street Settlement in 1927. She opened the Union of Girls' Schools Settlement (now the Peckham Settlement) in 1931. She visited the Peckham Pioneer Health Centre on 19 February 1939 and again on 12 July 1948 after seeing *The Centre* at the Odeon theatre in Peckham High Street.

Southwark News on 7 December 2006 described **PC Alf Matthews** as 'the longest serving police officer in the history of Peckham'. He started working at Peckham police station in 1959 and remained there for thirty-six years until his retirement in 1996.

Dr W. R. Matthews (1881–1973), who became Dean of St Paul's Cathedral, was christened at All Saints' Church, Blenheim Grove, and preached his first sermon there.

Francis May (1803-85), co-founder of the match making firm Bryant & May Ltd, lived in Rye Lane and Elm Grove. He attended the Peckham Quaker Meeting House in Hanover Street (now the main part of the Royal Mail Delivery Office in Highshore Road).

Richard May (1823-80) founded the timber firm R. May & Son Ltd which had premises at Acorn Wharf at the side of the Grand Surrey Canal near the Old Kent Road.

The **Revd John Maynard** (1600-65) founded Peckham's oldest church (known later

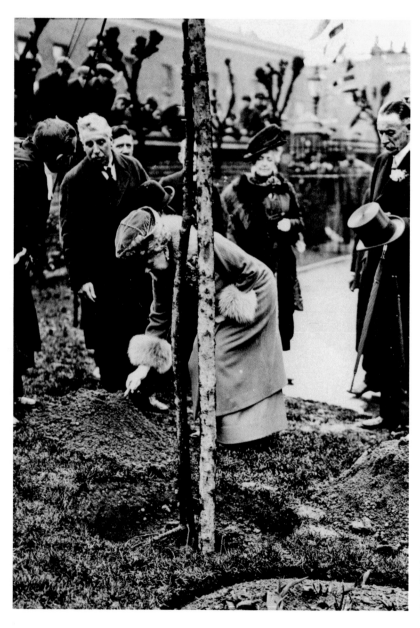

Queen Mary planted a tree at St Luke's Church.

as Hanover Chapel and now part of the Copleston Centre Church). It began in what today is Meeting House Lane.

When the President of the Council of Pitcairn Island, **James McCoy**, visited England he stayed with the Revd Andrew Augustus Wild Drew (q.v.) at St Antholin's vicarage.

Artist **Mark McGowan** grew up on the North Peckham Estate. His stunts attracted much media coverage including when he nudged a peanut from Peckham to Downing Street using only his nose.

Actor **Sir Ian McKellen** met Theatre Peckham pupils at the Harris Academy at Peckham on 29 March 2010.

Former SAS soldier turned author **Andy McNab** (a pseudonym) was abandoned as a baby, adopted and spent part of his childhood in Peckham. He was interviewed by Sue Lawley on *Desert Island Discs* in January 2006.

The vision of the **Revd Henry Meakin** (1855-1913) inspired the opening of London's first Central Hall at Bermondsey in 1900. He was Superintendent of the South London Mission (1906-8) and lived at 19 Glengall Road.

Actress **Amanda Mealing,** who played surgeon Connie Beauchamp in *Holby City*, was filmed in the White Horse at Peckham Rye in February 2007.

The **Earl of Meath**, chairman of the Parks and Open Spaces Committee of London County Council, opened the bandstand on Peckham Rye Common on 11 July 1889.

Johann Carl Gustav Mellin (*c.* 1830-1902), who was born in Heligoland, a British island territory off the German coast, established Mellin's Food factory in Stafford (now Staffordshire) Street in 1875.

Labour Party Leader **Ed Milliband**, MP was photographed in the *Guardian* on 11 August 2011 visiting Peckham, with the Shadow Home Secretary Harriet Harman (MP for Camberwell and Peckham), after rioting took place in Peckham and many other places in Britain.

Surrey cricketer **Charles Henry Mills** (1867-1948) was born in Peckham.

Dr John Milner (1688-1757) was pastor of the Meeting House known later as Hanover Chapel. He was also headmaster of the Peckham boarding school at which Oliver Goldsmith (q.v.) was an usher (assistant teacher).

Peckham born **Dr Thomas Milner** (1719–97) was the son of Dr John Milner (q.v.). In 1759 he was elected physician to St Thomas's Hospital.

Actor **Patrick Monckton** visits Everthorpe Road to see his friend Michael Keating (q.v.).

Peckham's first English Heritage Blue Plaque commemorates **Dr Harold Moody** (1882-1947) at 164 Queen's Road. He was a popular West Indian doctor who founded the influential League of Coloured Peoples.

During a tram crash on Dog Kennel Hill on 31 July 1925 **Geoffrey Morris** of Ondine Road was injured. When its brakes failed, a tram ran backwards from the top of the hill and hit another one waiting at the bottom. The conductor of the stationary tram, Harry Turvey of 2 Caulfield Road, was also injured. Most of the other injured passengers were East Dulwich residents.

A bench in Peckham Rye Park commemorates **Peter Morris** (1936-2001) who was an active Peckham Society member. The bench was made from yarran wood by Mark Folds (q.v.).

Artist and poet **William Morris** (1834-96) spoke about socialism to the Peckham and Dulwich Radical Club at 144 Rye Lane on 12 January 1886. He also delivered a lecture to a literary society in a schoolroom in the High Street, Peckham, on 9 February 1887.

PC Jonathan Morrison, who grew up in Peckham, became a presenter on BBC1's *Crimewatch UK* in 2004.

Oswald Mosley (1896-1980), founder of the British Union of Fascists, spoke in the open air at the Peckham Rye end of Rye Lane.

Robert Mugabe, President of Zimbabwe, visited Sally Mugabe House, 69 Bellenden Road, on 18 May 1994.

Actress **Carmen Munroe**, a star of the popular Peckham based comedy *Desmond's*, opened the fête at Lympstone Day Nursery on 21 May 1995.

The first editor of the *Oxford English Dictionary*, **Sir James Augustus Henry Murray** (1837-1915), lived at 6 Beaufort Terrace on the north side of Nunhead Lane close to Peckham Rye. Later he moved to 5 Denman Road.

Len Murray (1922-2004), who became General Secretary of the Trades Union Congress and later a member of the House of Lords, lived at 104 Talfourd Road from 1949 until 1953.

Author **John Middleton Murry** (1889-1957) was born at 20 Ethnard Road. When his family moved to Copleston Road he attended Bellenden Road Higher Grade School.

A bust of Dr Harold Moody, made by his brother Ronald, is on permanent display at Peckham Library.

Peter Morris and John Hazell ran a Peckham Society stall at an Open Day in Nunhead Cemetery.

Dame Jinty Nelson, Professor of Medieval History at King's College (1993-2007), lives in Oglander Road.

Architect and surveyor **Arthur Shean Newman** (1828-73) lived in Glengall Road. He designed many churches and was Surveyor to Guy's Hospital. He was buried in Nunhead Cemetery.

Botanist, entomologist and ornithologist **Edward Newman** (1801-76) is included in *Nunhead Notables* by Ron Woollacott. He was 'one of the forty most distinguished naturalists in the world'. He died at his residence at 7 York Grove and was buried in Nunhead Cemetery.

Kwame Nkrumah, who became President of Ghana, visited the home of Dr Harold Moody (q.v.) at 164 Queen's Road.

The chairman of The Pensions Regulator, **David Norgrove,** lived in the school keeper's house at Peckham School when he was a child. His father was the school keeper.

Historian Dame Jinty Nelson has lived in Oglander Road since 1972.

'Peckham Dog Which Has Won 90 Prizes' was the heading in the *South London Press* on 9 October 1931 above a photograph of 'Sunset of Gladeland', a champion Irish setter owned by **Mr W. O'Bolger** of Peckham.

Journalist and Whorlton Road resident **Jamie Oliver** wrote an unusual book about death entitled *Get Dead*.

TV chef **Jamie Oliver** was photographed wearing a fat suit in Bellenden Road in August 2006. This was to advertise *Back to School Dinners* and to warn youngsters about fatty foods.

Herman Ouseley spoke about social responsibility at Peckham Methodist Church on 20 November 1994.

Founder of the Blood Donor Service **Percy Lane Oliver** lived at 210 Peckham Rye before moving to 5 Colyton Road, opposite Peckham Rye Park, where a Greater London Council blue plaque states:

> Percy Lane Oliver
> 1878-1944
> Founder of the First Voluntary Blood Donor Service lived and worked here.

Archivist **Richard Olney** wrote *Church and Community in South London: St Saviour's Denmark Place 1881-1905* published in 2011.

Anne Winifrede O'Reilly was head of Peckham Central School (1940-46). During the Second World War she was a voluntary organiser of Londoners Meals Service Centres, known as British Restaurants. She was responsible for twenty-six centres providing 30,000 meals a week.

A law student from Peckham **Hannah Osunsina,** who grew up on the North Peckham Estate, was crowned 'Miss Black Britain' in 2007.

Herman Ouseley, who is now **Lord Ouseley of Peckham Rye,** used to live at 181 Choumert Road.

Dame Anne Owers, who was Chief Inspector of Prisons for England and Wales (2001-10), lived at 77 Oglander Road in the 1970s.

Independent film producer **David Parfitt** is a former Peckham resident who was part of the team who successfully protested against the proposed route for the Channel Tunnel rail link that would have destroyed Warwick Gardens. He was producer or co-producer of many famous British films. He won an Oscar for best picture of 1998 (*Shakespeare in Love*) and BAFTA awards for the same film and for *The Madness of King George* (1995).

Artist **Beatrice Parsons** (1869-1955) was born at 2 (later 83) Montpelier Road. Her family moved when she was about six years old to 3 (later 8) York Grove. Queen Mary (q.v.) bought many of her paintings. Queen Elizabeth II owns thirty of Beatrice Parsons' watercolours.

Peckham resident **Freddie Parsons** (1934-2006), a pioneer stock car driver, raced in the first ever British meeting at New Cross Stadium on Good Friday 1954. He had the distinction of being the first British driver to win a race.

Murderer and burglar **Charles Peace** (1832-79) lived a life of seeming respectability at 5 Evelina Road. This notorious criminal was Nunhead's 'Dr Jekyll and Mr Hyde'.

Dr Innes Pearse (1889-1978) was co-founder of the Peckham Pioneer Health Centre with Dr George Scott Williamson (q.v.). An English Heritage Blue Plaque outside 142 Queen's Road commemorates where this world-famous health experiment began in 1926. *See Peckham and Nunhead Through Time* (page 39).

Garden expert **Dan Pearson** has written a lavishly illustrated book about his amazing garden in Peckham. *Home Ground: Sanctuary in the City* is the most detailed book ever written about a garden in SE15.

Author **Mrs C. S. Peel** (1872-1934) wrote in her autobiography *Life's Enchanted Cup* about her active involvement in the Peckham Pioneer Health Centre before it moved to the new building in St Mary's Road in 1935.

Athlete **Mary Peters** was in the procession when the Olympic Flame was carried along Peckham High Street and Queen's Road on 26 June 2004.

The first British-born Conservative woman MP, **Mabel Philipson** (1886-1951), was born at 1 Copeland Avenue, Copeland Road.

Painter, writer and composer **Tom Phillips** lives in Talfourd Road and has a workshop in Bellenden Road. Among his local creations are the *I Love Peckham* mosaics and unusual street lamps in Bellenden Road as well as the gates and archway in McDermott Grove Nature Garden.

At the launch of Urban Cricket on 2 May 2006, England player **Kevin Pietersen** went to the Ledbury Estate to encourage local youngsters to play the game.

The house where Charles Peace lived no longer exists.

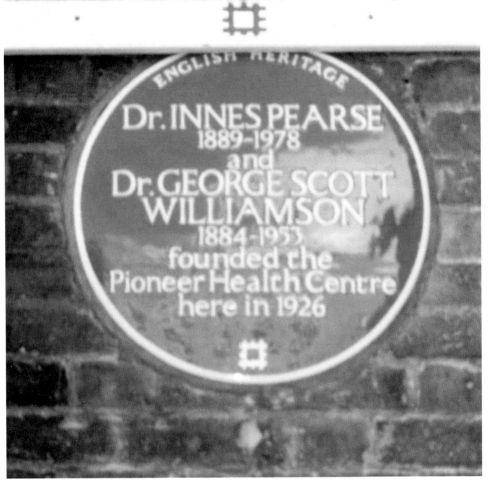

Much interest continues to be shown in the Pioneer Health Centre established in 1926 at 142 Queen's Road.

Toy maker **Albert Plumb** had a shop at 25 Grenard Road from which people hired scooters for a penny. The story of this enterprise was told in an illustrated article in *The Evening News* on 27 June 1923.

Peckham resident **Jim Pollard** wrote *Rotten in Denmark*.

Artist **Jacqui Poncelet's** unusual house at the rear of 117 Bellenden Road was featured in the *Telegraph Magazine* on 12 May 2007.

George Potter (1887-1960), known as Father Potter of Peckham, wrote two books about his experiences as a vicar – *Father Potter of Peckham* and *More Father Potter of Peckham*. He was vicar of St Chrysostom's, Peckham Hill Street, 1923 to 1938.

Artist **John Arthur Poulter** (1824-1921) was born in Deptford Lane (now Queen's Road). He painted many watercolours of rural Peckham in the nineteenth century.

In *A Tour Through the Whole Island of Great Britain*, compiled in 1724-7 by Daniel Defoe, it says: 'suppose you take your view from the little rising hills about Clapham, if you look to the east, there you see the pleasant villages of Peckham and Camberwell, with some of the finest dwellings about London; as ... the **Lord Powis's** at Peckham.'

Author **Terry Pratchett** gave a talk at Peckham Library on 6 March 2003 to celebrate World Book Day.

John Prescott, MP (now **Lord Prescott**), when he was Environment Secretary, went to Peckham on 10 October 2000. He wore an 'I love Peckham' badge as he gave details of the Neighbourhood Renewal Fund – an £800 million aid package to fight poverty in England. On this visit John Prescott was accompanied by Chancellor Gordon Brown (q.v.).

Russell Profitt was in charge of Southwark Council's Peckham Programme. When the Queen presented him with an MBE in 2009, he explained that he had been trying to make Peckham a better place. The Queen asked him: 'Is it?' He replied: 'Yes.'

Henry Prosser (1816-1888), a noted Surrey artist, painted views of Nunhead.

Artist **Albert Robert Quinton** (1853-1934) was born in Commercial Road (now Way). This is mentioned in A. R. Quinton's *England: A portrait of rural life at the turn of the century*.

Dr Thomas Raffles (1788-1863) became an independent minister. In 1800 he was sent to a boarding school in Peckham. This was the school attended by William Fry Channell (q.v.). Among his school friends was his lifelong friend Richard Slate (q.v.). He joined the congregation of William Bengo' Collyer (q.v.).

Writer **William Brighty Rands** (1826-82) lived at Hopewood Villa, Choumert Road, and later lived at Luton Villa, 67 Ondine Road, where he died. He was known as 'the laureate of the nursery' and was esteemed for his poems and fairy tales for children.

The first person to use hypo as a fixing salt was **Joseph Bancroft Reade** (1801-70) who was a clergyman, microscopist, astronomer and pioneer of photography. While living in Peckham in 1837 he produced paper negatives by means of gallic acid and nitrate of silver; he was the first person to do so.

The grandfather of former USA President Ronald Reagan, **John Reagan**, was born in Bexley Street, Peckham, in 1854. Part of the Friary Estate now occupies the site.

A photograph taken in 1843 in the High Street, Peckham, is preserved in the Cuming Museum. It is a daguerreotype and by far the earliest photograph to survive of any part of the London Borough of Southwark. It was taken by chemist **Theodore Smith Redman** from his premises at 6 Shards Terrace (now 99 Peckham High Street).

Millwall footballer **Frank Reeves** was born in Peckham. He played in 196 games.

Theodore Smith Redman photographed the High Street as early as 1843. This photograph is stored at the Cuming Museum.

Celebrated international artist **Liam Roberts** attended an exhibition of his work at the Pioneer Building, St Mary's Road, in May 2001.

The British School of Motoring has its origin in Peckham before 1910. The founder was **Stanley Roberts** who had a motor garage at 65 Peckham Rye. A coachman begged him to teach him how to drive and offered to pay for the privilege.

Singer **Paul Robeson** visited Dr Harold Moody (q.v.) at 164 Queen's Road.

A young criminal who grew up in Peckham, **Michael Rolle**, was featured in *Make Me Honest* on BBC2 on 15 April 2004. With a mentor from a privileged background, he was able to turn his life around.

Wholesaler D. Rose Ltd celebrated its centenary in 1966. The founder was **Daniel Rose** who had an aunt who ran a small shop in Bermondsey. She loaned him the money to buy a handcart and the minimum of merchandise which he sold on the streets of Peckham.

In *Give Me This Mountain: An Autobiography* **Dr Helen Roseveare** wrote about her experience of staying at the Franciscans' headquarters in Peckham during the Blitz.

Musician **Francis Rossi**, who was born in Peckham in 1949, was a co-founder of Status Quo.

A Bus and Tramway Ticket Holder was invented and patented in 1905 by **Archer Alfred Round**. Some years later he lived at 133 Copleston Road.

Charles William Rous (1930-96) was born at 73 Brayards Road. He became editor of *Motor Cycle News*.

Victorian garden artist **Ernest Arthur Rowe** (1862-1922) lived at 9 Ardsley Terrace, Placquett Road (now 150 Copleston Road). Queen Mary (q.v.) purchased at least fifteen of his paintings.

Mrs John Ruskin wrote a letter from their home at Denmark Hill on 7 May 1847 and stated 'Mrs Ruskin, John and I went to Dulwich Gallery today, but couldn't get in. We drove on to Peckham and took a long walk. John and I went into a Chalk Pit, the only one I ever saw, and the country is looking most exquisitely beautiful; the shades of green and the long hedgerows are beyond anything I ever saw.'

The Peckham Map Terrace outside Petitou Café, at 63 Choumert Road, was designed by local ceramicist **Loraine Rutt**.

Maria Susan Rye (1829-1903) arranged the emigration of pauper children to Canada from Avenue House, 1 Rosewall Road, Bull Yard, off the High Street.

Writer **Vane Ireton Shaftesbury St John** (1838-1911) was a pioneer of boys' journals. He started and edited *Boys of England*. He was the author of many story books for boys. He lived at 53 Scylla Road.

Author **Beram Shapurji Saklatvala** (1911-76) lived at 263 Bellenden Road and then 52 Elm Grove. While in SE15 he wrote a number of books under the pseudonym Henry Marsh including *Slavery and Race: The story of slavery and its legacy for today*.

Dr Alfred Salter, MP and his wife **Ada** attended the Peckham Quaker Meeting House in what today is Highshore Road.

Bus driver **Kevin Salter** received a Transport for London Bus Award for Excellence and Bravery in March 2012. This was for getting all his passengers safely off his number 12 bus after thugs hurled paving slabs through its windows in Peckham High Street during the riots, which occurred in many parts of the country in August 2011.

Television personality **Henry Sandon** moved to Peckham in 1935. His father had a shop in Queen's Road. Henry was hauled out of bed in 1936 to see the Crystal Palace on fire.

The only person convicted in a British court of Nazi war crimes, **Anthony Sawoniuk**, lived in King's Grove for a short time and later became a ticket collector at Peckham Rye Station until he retired in 1986.

William Griggs photographed Avenue House.

Dr Alfred Salter was a GP and an MP.

A television programme on BBC2 on 4 July 2012 *The Secret History Of Our Streets* paid a glowing tribute to Ada and Alfred Salter's work in Bermondsey.

Henry Sandon spent some of his early years in Peckham.

Bob Smyth spoke at the Peckham Society's Silver Jubilee celebrations at the Peckham Settlement on 7 October 2000.

Writer **Henry Carl Schiller** (1807-81), who was also an artist, died at Manilla House, Peckham Rye. In 1858 he invented a method of laying deep sea telegraph cables.

Piano tuner and composer **Charles Seaton** (1838-1902) lived at Hope House, Rye Lane, and then Handel House, 76 Peckham Rye. He ran a music stall at the Crystal Palace.

Caroline Gardens in Asylum Road are named after **Caroline Sophie Secker** (1789–1845) who was a resident of the Licensed Victuallers' Asylum. She was the widow of Sergeant James Secker, of the Royal Marines, who helped to carry Horatio Nelson to the cockpit after he was mortally wounded at the Battle of Trafalgar in 1805.

Gordon Selfridge, owner of Selfridge's store in Oxford Street, went to Peckham to visit Holdron's store in Rye Lane shortly after he acquired a controlling interest in it.

When he was Bishop of Stepney, **Dr John Sentamu** (now the **Archbishop of York**) came to Peckham in 2000 to take part in a BBC film about Dr Harold Moody (q.v.).

Lord Shaftesbury (the 7th Earl 1801-85) was chairman of the emigration home in Peckham run by Maria Rye (q.v.). He also visited Peckham in 1874 when, in the Quaker Meeting House in Hanover Street (now Highshore Road), he presided over the second annual meeting of the Boys' Home in Meeting House Lane.

Lord Soper preached at Peckham Methodist Church in 1984.

Herbert Shalders was Mayor of Camberwell (1926-7) and the head of Peckham Central Boys' School in Choumert Road.

Broadcaster **Olive Shapley** (1910-99), who was born at 10 Tresco Road, wrote in her autobiography *Broadcasting a Life*: 'When I was twelve we moved from Peckham to Dulwich. I never grew as attached to Dulwich Park as I was to Peckham Park.'

One of America's leading civil rights campaigners, the **Revd Al Sharpton,** went to Peckham on 21 October 2002 and visited the spot where Damilola Taylor (q.v.) was murdered.

Martin Shaw, who was co-presenter on BBC TV's popular *Ebony on the Road* show, died in 1989 aged twenty-eight. He was brought up in Havant Way, went to Wilson's Grammar School and then moved to Daniel Gardens before graduating in law at Kent University. He became music editor of *The Voice*.

As a well-earned tribute to archaeologist **Harvey Sheldon,** who lives in Oglander Road, a book was published entitled *Londinium and Beyond: Essays on Roman London and its hinterland for Harvey Sheldon*.

Singer **Anne Shelton** (1922-94) was a customer in Jones & Higgins, Rye Lane Market and Deighton's which made many of her dresses.

An England cricketer who became a Bishop, **David Sheppard** (1929-2005), lived at 12 Asylum Road when he was Bishop of Woolwich. While there he wrote *Built as a City* and opened Tuke School in Harder's (now Wood's) Road.

In *An Aspect of Fear* **Grace Sheppard** (1935-2010), wife of David Sheppard (q.v.), referred to her membership of the Parochial Church Council of St John's, Meeting House Lane, and the Clifton Crescent Action Group.

The Royal Arsenal Co-operative Society's 100th branch was opened in St George's Road (now Way) on 18 June 1935 by **Mr J. T. Sheppard**, chairman of the Society. In the first hour and a half after the opening ceremony 1,068 customers made purchases.

Classical scholar and Provost of King's College, Cambridge, **Sir John Tresidder Sheppard** (1881-1968) was born in Peckham. He wrote *Greek Tragedy*, *Oedipus Tyrannus* and *The Pattern of the Iliad*.

Leslie Sherwood, who lived at 138 Copleston Road, compiled *Camberwell Place and Street Names and Their Origin*, which was issued by Camberwell Borough Council in 1964.

Lewis Silkin (1889-1972), who was MP for Peckham (1936-50) and became a member of the House of Lords, had two sons who became Members of Parliament – Samuel and John.

Artist **Alan Skidmore**, who lives in Chadwick Road, displayed his paintings of Peckham Rye Common and Park in Petitou Café, 63 Choumert Road, in December 2011.

Nonconformist preacher **Richard Slate** (1787-1867) attended Peckham Collegiate School. He was the biographer of Nonconformist Oliver Heywood (1630-1702) who was excommunicated for not using the prayer book.

When he was Culture Secretary, **Chris Smith**, MP, who is now a member of the House of Lords, opened Peckham Library on Monday 15 May 2000.

The Peckham Society was founded in 1975 by **Bob Smyth**, a journalist who wrote *City Wildspace* which includes Goldsmith Road Nature Garden, McDermott Road Nature Garden (now McDermott Grove Garden) and Nunhead Cemetery.

Donald Soper (1903-98), who became **Lord Soper**, attended Haberdashers' Aske's School, Hatcham. On the school field in Nunhead in 1921 he killed a lad while playing cricket when a ball he bowled hit the batsman's heart. The only time Lord Soper preached at Peckham Methodist Church was on 3 June 1984 during events to celebrate the 10th anniversary of the present church and the 150th anniversary of the

Milton Syer was an inventor.

first chapel; the latter building in Staffordshire Street is the oldest part of the Peckham Settlement's premises.

Muriel Spark's novel *The Ballad of Peckham Rye* mixes facts and fiction about Peckham's history, but readers who are not experts on Peckham's fascinating history do not know what is true and what is a product of the author's imagination. Muriel Spark, who became a Dame, lived in Camberwell. *See Camberwell Through Time*, page 30.

Charles Lewis Spitta owned a mansion where the Harris Academy at Peckham is today. He and his wife Ann had a daughter Catherine who was baptised on 28 February 1785. The mansion became a private mental hospital called Peckham House where Hannah Chaplin (q.v.), mother of comedian Charlie Chaplin, was a patient.

The **Revd Charles Haddon Spurgeon** (1834-92) laid the foundation stone of James's Grove Baptist Church (now North Peckham Baptist Church in East Surrey Grove) on 19 July 1870. He visited the newly opened Peckham Rye Baptist Tabernacle in 1891 and commented: 'I have never seen a better building.'

Milkman **Frank Staples** (born 1923), who attended Adys Road School and Peckham Central School, Choumert Road, wrote about his experiences in *Fifty Years in 'The Milk Game.'* He once worked for 340 days without a single day off.

Tommy Steele practised guitar playing in rooms above a shop at 163 Rye Lane. These were later used as offices by spy Gordon Lonsdale (q.v.).

Professor Otakar Steinberger (1872-1939) lived and worked at 142 Queen's Road for ten years after the Pioneer Health Centre moved out in 1929. There he had busts of famous people he had modelled in bronze including Charles Lindberg and Amy Johnson. His firm produced thousands of models, medallions, plaques, busts, paper-weights and bookends.

Jennifer Stephens wrote *The Peckham Settlement 1896-2000*. *See* **HRH The Princess Margaret, HRH Queen Mary** and **HRH The Countess of Wessex.**

Joseph Stiles (?1850-1921) was the founder and manager of the Peckham Working Boys Home in Meeting House Lane. This was started in 1872 to provide shelter, clothing, employment and a simple education for destitute boys.

Sarsaparilla, a fruity drink popular early in the twentieth century, was made by **Sidney Stratford** from a secret recipe in a workshop in the back garden of his home at 91 (now 231) Bellenden Road.

Alice Street founded the London Flower Lovers' League and has a memorial in Peckham Rye Park.

The popular television comedy *Only Fools and Horses* made Peckham famous. Scriptwriter **John Sullivan**, who grew up in Balham, was asked why he had set the comedy in Peckham. He replied: 'When I was a teenager, it was the toughest area I knew. It was a place you avoided, if you could.'

Edith Summerskill, who became **Lady Summerskill** in 1961, married Dr E. Jeffrey Samuel when he was medical officer at Peckham House, a private mental hospital which was demolished to make way for Peckham School. The Harris Academy at Peckham now occupies the site.

Mr Milton Syer ran a large store at 36 Rye Lane (at the corner of Hanover Street now Highshore Road). He invented several forms of cisterns and other sanitary fittings, including The Peckham Valveless Syphon Cistern supplied to His Majesty's Board of Works and the Admiralty.

The **Revd Vivian Symons** (1913-76) spent much time knocking down All Saints' Church, Davey Street, and taking the bricks, stonework and timber to Biggin Hill where a new Anglican church was built and is still in use. The complete dismantling of All Saints' took over three years. This was done because of the shortage of building materials after the Second World War. All Saints' was not going to be restored for use and had the right type of mortar for easy dismantling of the bricks.

Actor **Colin Tarrant** (1952-2012), who played Inspector Monroe in *The Bill*, lived in Choumert Road.

Ten-year-old **Damilola Taylor** was stabbed to death with a broken bottle in a stairwell on the North Peckham Estate on 27 November 2000. Damilola's death received a huge amount of national publicity. A memorial to him is in a playground at Oliver Goldsmith School, where he was a pupil.

In 1885 **Helen Taylor**, stepdaughter of John Stuart Mill, became President of the newly opened Camberwell Radical Club at 78 Peckham Park Road.

When **Margaret Thatcher** was Prime Minister she opened the Habinteg housing development in Brock Street on 30 September 1980.

The founder of Abbey Rose, **Gwyn Reid Thomas**, bought the bankrupt business of Abbott Iles & Co. in 1902. There were premises at Canal Head at that time. Mr Thomas renamed the business Abbey Rose because he was keen on churches and flowers, and ABB starts most listings.

A memorial to Damilola Taylor is in a playground at the school he attended.

Jessie Thomas became headmistress of Meeting House Lane School in 1930. In the early years of the Second World War she organised the evacuation of 500 disabled children from her own and three other schools. At the age of eighty-seven she wrote *Hope for the Handicapped – A Teacher's Testament*. She died in 1986 aged 107.

John Birch Thomas wrote his autobiography to tell his grandchildren about his life from the 1860s in Peckham up to his manhood. It was published as *Shop Boy*.

In 1842 **Francis Thompson** (1808-95), a noted railway architect, bought land in north Peckham. He was involved in the building of twenty houses in Nelson Square (now a westward extension of Furley Road) and possibly twenty-four in Trafalgar Square (later renamed Buller Square). He lived in Trafalgar Square.

John George Thompson (1831-77) was the founder principal of St Mary's College, Hanover Park, in 1868.

The **Revd George Ernest Thorn** (1862-1943) wore a suit of medieval armour when he preached in the Church of the Strangers, 43 High Street, on 'Put on the whole armour of God'. To publicise the sermon he walked in Peckham streets wearing the metal suit.

Will Thorne worked in the gasworks in the Old Kent Road. He played a major role in establishing the National Union of Gasworkers and General Labourers. He was General Secretary and later became an MP.

Lord Valentine Thynne ran a rock 'n' roll club at 43 Peckham High Street in 1960.

One of **Thomas Tilling's** horse omnibuses is preserved in London's Transport Museum at Covent Garden. In 1851, the year of the Great Exhibition at Hyde Park, Tilling cashed in on the event by putting his first omnibus on the road and naming it *The Times*. His headquarters were at Winchester House in the High Street.

Peckham resident and artist **Jake Tilson** was featured in the *Telegraph Magazine* on 6 May 2006 after his first cookbook, *A Tale of 12 Kitchens*, was published.

Peckham's first ever poet laureate, New Zealand born **Jillian Tipene**, achieved this accolade in 1998.

Mathematician **Isaac Todhunter** (1820-84) became an usher (assistant teacher) in a Peckham school.

Lord Trevor (1658-1730) owned a mansion in what is now Peckham Hill Street. It had previously been owned by Sir Thomas Bond (q.v.).

John Thompson founded St Mary's College.

Comedian **Tommy Trinder** opened 'Jax', a ladies' outfitter's shop at 135A Rye Lane, on 1 September 1950.

Johnny Trunley (1898-1944), known as the 'Fat Boy of Peckham', weighed 11 stones 4 pounds when he was about five years old. He attended Reddin's Road School. He appeared on theatre and music hall stages. He acted in films including *Four Just Men* written by Edgar Wallace (q.v.).

A blue plaque commemorating **Edward Turner** (1901-1973) was unveiled at 8 Philip Walk on 25 October 2009. He was an engineer and designer of Triumph motorcycles, the Ariel Square Four and the Daimler V8 engine. He lived and worked at that address. Stephen Humphrey, Archivist in Southwark Local History Library, researched when and where Edward Turner lived in Peckham.

Television star **Michael Underwood** visited Highshore School, Bellenden Road, in 2011 when a new minibus was presented.

The Chief Executive of the Joseph Rowntree Foundation, **Julia Unwin**, lived at 63 Oglander Road.

Artist **Alexander Augustus Vale** (1922-2007) was born in Peckham. He accepted a traineeship in the graphic design studio run by Holdron's store in Rye Lane. One of three sets of postage stamps he designed for the Botswana government earned him an *Observer* Commonwealth Design of the Year Award.

Yorkshireman **Canon Harry G. Veazey** (1865-1951) was vicar of St Mark's Church in Cobourg Road (1902-49). He was involved with the United Girls' Schools Mission (which became the Peckham Settlement) for many years. His son, the Rev Hurford C. H. Veazey, was vicar of St Silas, Nunhead.

HM Queen Victoria (1819-1901) often travelled through Peckham along Deptford Lane on her way to the Royal Naval School at New Cross (where Goldsmiths University of London is today). The lane was renamed Queen's Road in her honour.

On 3 September 1989 **Dr John Vincent** was the first serving President of the Methodist Conference to preach at Peckham Methodist Church since the Methodist Church was formed in 1932.

In *A Tour of Camberwell*, published in 1954, **Olive M. Walker** included Peckham (which was then part of the Metropolitan Borough of Camberwell). She quoted the travel writer H. V. Morton who wrote about Peckham Rye Park: 'It is one of the prettiest parks in London, and others would do well to copy it.'

Author **Edgar Wallace** (1875-1932) was a pupil at Reddin's Road School (where Haymerle School is today). One of his novels was based on the life of Charles Peace (q.v.). He wrote motion picture stories including *King Kong*.

Television food expert **Gregg Wallace** was born in Kincaid Road.

The story of **Ashley Walters** is told in *Asher D so solid*. He grew up in Southampton Way opposite the North Peckham Estate.

The **Revd Cyril Ambrose Walton** (1877-1916) served at St Jude's, Meeting House Lane (1900-5). He was chaplain on the First World War light cruiser HMS *Chester*. He was killed on 31 May 1916 during the Battle of Jutland.

Known as the 'Little Woman of Peckham', **Lucy Wanmer** was born in the eighteenth

century. Her height was exactly 32 inches. While living in Peckham she opened a school and was an able disciplinarian. She died in 1821.

Cricketer **Nicholas Wanostrocht** (?-1876) was author of *Felix on the Bat; being a scientific enquiry into the use of the Cricket Bat, together with the History and use of the Catapulta* (first published in 1845). As a boy he was a pupil of the celebrated cricket coach Harry Hampton whose cricket field was at the Rosemary Branch at the corner of what today are Southampton Way and Commercial Way.

Boxer and artist **James Ward** retired to the Licensed Victuallers' Asylum (now Caroline Gardens in Asylum Road).

In 1960 the **Revd John Ward** (1929-2007) began working in Peckham as a Roman Catholic priest for three years. He became the Archbishop in Wales.

Rosemary Warhurst wrote *A view of Dulwich, Peckham and Camberwell around 1300.*

Warwick Gardens were named after **Alderman Alfred Charles Warwick** (?-1951) who was Mayor of Camberwell (1935-6).

Commercial artist **Edward John Waters** (1882-1952) lived at 26 Ryehill Park.

The founder of Pitt Street Settlement was **Charles Lisle Watson** (1890-1970). About 200 mourners attended his funeral service in Our Lady of Sorrows Roman Catholic Church in Friary Road.

Surrey cricketer **Edward Alfred Watts** (1911-82) was born in Peckham.

Turner prize winning artist **Gillian Wearing** made a video of herself dancing in the Aylesham Centre in 1994.

Animal painter and author **Harrison William Weir** (1824-1906) lived in Lyndhurst Road (now Way) nearly opposite Eliza Cook (q.v.). When the *Illustrated London News* was founded in 1842 he was employed as a draughtsman on wood and an engraver from the first issue.

On 17 July 1783 hymn writer **Charles Wesley** (1707-88) visited a family in Peckham.

Founder of Methodism **John Wesley** (1703-91) visited Peckham at least ten times. He began writing his final will on 8 January 1789 while staying in the Surrey village of Peckham. His wife Mary was buried in the churchyard of St Giles's Church, Camberwell.

Edward Waters painted this view from 26 Ryehill Park. At the top left can just be seen Brunel's water towers that once stood either end of the Crystal Palace. It was painted after the Crystal Palace had been burnt down in 1936.

A war memorial stood in the grounds of Pitt Street Settlement.

HRH The Countess of Wessex is the Patron of the Peckham Settlement. She made her first visit as Patron on 22 September 2003 to open the All Nations Nursery Baby Unit.

Sir Jack Allan Westrup (1904-75) was brought up at 46 Copleston Road (where flats built in the 1980s now stand). He and his family attended St Saviour's Church where Jack deputised as organist. He was elected as President of the Royal College of Organists (1964-66).

Charlie Whelan, former Press Secretary to Chancellor Gordon Brown (q.v.), lived in Ansdell Road when he was interviewed in the *South London Press* on 15 December 2000. When asked what he most liked about Peckham he replied: 'I like the cosmopolitan nature of it with all the different nationalities.'

Architect **Robert Phillips Whellock** (1834 or 5-1905) designed the Central Hall in the High Street (now 43 Peckham High Street), Peckham's second public library, which became Livesey Museum, and Nunhead Library.

Artist **Annie Whiles,** who lived in Green Hundred Road, worked with Free Form Arts Trust to create the 'International Carpet of Flowers' in Moncrieff Place. It consists of 500 silk flowers each representing the national flower of all the countries in the world.

When **Sidney Donald White** (1904-76) was nine years old he sang a solo at Orchard Mission, Mission Place. He became Pastor in 1939. During the Second World War the building was a Rest Centre for people who had been bombed out. When Don White died he had spent over fifty years in service at the Mission.

The origin of Whitten Timber Ltd in Peckham Hill Street goes back to 1919 when **Mr W. H. Whitten** started trading from his home by selling second-hand timber, doors, windows etc from London County Council schools that were being replaced by more modern buildings. His business prospered so in 1921 he moved to premises adjacent to the Peckham branch of the Grand Surrey Canal and began trading in imported softwoods.

In about 1814 **Dr Josiah Henry Wilkinson** (*c.* 1762-1842), of what today is Queen's Road, bought the head of Oliver Cromwell, which he showed to his patients. In 1960 it was buried in a secret location in the grounds of Sidney Sussex College, Cambridge.

Former boxing heavyweight champion **Derek Williams**, who was brought up in Peckham, has campaigned to encourage youngsters to steer away from crime.

Archbishop of Canterbury **Dr Rowan Williams** preached at the Festival Patronal Mass at the Parish Church of St John Chrysostom with St Andrew, Meeting House Lane, on 16 September 2007.

Dr George Scott Williamson (1884-1953) was the co-founder of the Peckham Pioneer Health Centre with Dr Innes Pearse (q.v.). In *The King's England: London* Arthur Mee wrote, 'In setting up this great Health Centre Peckham has set a fine example to the densely peopled areas of our great cities.'

Wilson's cycle shop in Peckham High Street was opened in 1882 by **Harold Wilson**. He opened his first shop in Hill Street in about 1870. The firm is Peckham's oldest business still in existence.

Harold Wilson, MP (1916-95) spoke under a tree at the northern end of Peckham Rye during the 1964 General Election campaign. As Labour won, he became Prime Minister.

The first black Pentecostal Church to be established in England was started by a Ghanaian minister, **Thomas Brem Wilson**, in 1906 in the former Sumner Road Primitive Methodist Chapel (which still exists).

In 1864 menagerists who continued the work of **George Wombwell** (1777-1850) brought thirty-two vans of 'Wombwell's wild beasts' to Peckham Rye Common where they 'held possession for a time', according to W. H. Blanch (q.v.).

Mary Woods was killed by a police officer who was under the influence of alcohol.

Bishop Wilfred Wood officiated at the opening of a close named after him off Moncrieff Street. This was on 6 December 1989 when he was Bishop of Croydon.

On 15 July 1996 **Mary Geraldine Woods** was sitting on a wall at the corner of Goldsmith Road and Peckham Hill Street eating a bag of chips when she was killed by a car which crashed into her. Three young children suffered the loss of their mother. An off duty police constable was sentenced at the Old Bailey for driving while under the influence of alcohol. He was given a five-year prison term and banned from driving for ten years.

Author **Kathleen Woodward** (1897-1961) was born at 7 Stanton Street. Her first book was *Queen Mary: A Life and Intimate Study*. Queen Mary (q.v.) made a number of visits to Peckham.

Dr Francis James Woollacott (1865-1927), who was a specialist in the treatment of infectious diseases, lived at 6 York Grove when he was a schoolboy. He was buried in Nunhead Cemetery.

Nunhead's leading historian, **Ron Woollacott,** is also the energetic chairman of the Friends of Nunhead Cemetery. He has written many books on Nunhead and Peckham.

Methodist educationist the **Revd Dr Herbert Brook Workman** (1862-1951) was born in Peckham. He was Principal of Westminster Training College (1903-30). He was the son of the Revd John Sansom Workman who was instrumental in the building of the Wesleyan Chapel in Queen's Road that opened in 1865 and was demolished in 1972.

Actor **Trix Worrell** created *Desmond's*, a popular sitcom based in Peckham. He was born in St Lucia and raised in Peckham.

Chemist **Richard Cranfield Wren** (1861-1930) was born in Peckham. He was General Manager of Potter & Clarke, manufacturing druggists and chemists at Aldgate. He wrote *Potter's Cyclopaedia of Botanical Drugs*.

Author **Evie Wyld**, who grew up in Choumert Road, was pictured in *Southwark News* on 16 July 2009 with her first novel *After the Fire: A Still Small Voice*. She works in Review bookshop, 131 Bellenden Road, owned by Peckham resident Roz Simpson.

The political vendetta among Armenian refugees claimed three victims in Peckham. **Gorgie Yannie** (or Yannia) shot dead two Armenian men, Aram Grigorian (twenty-five) and Tigran Izmirian (thirty-two), at Peckham Rye on 4 November 1903. The murderer, who then killed himself, lodged in Moncrieff Street. The murdered men, who came from Russia, were members of the Huntchakist Society whose offices were at 85 Peckham Rye. The murderer was a member of an organisation known as Apiarists or Alfarists. The Armenian club at Peckham Rye was a front for a secret society dedicated to freeing Armenia from Turkish rule.

Actress **Emily Young** played in *Kiss of Life*, which was originally titled *Helen of Peckham*. Part of the film was shot in 'a nice little street' in Peckham, according to an article in the *Guardian* on 23 May 2003.

Cabaret aerialist **John Paul Zaccarini** lived in Peckham during his early twenties. He was interviewed in *The Pulse* in the *South London Press* on 10 January 2003.

Soviet Ambassador **Leonid Zamyatin** visited Gloucester Primary School in December 1988. He delivered a letter from Raisa Gorbachev, wife of the Soviet Leader, thanking the children for inviting her to the school. Mrs Gorbachev, a former teacher, said she had intended to come but an earthquake in Armenia meant she had to return home immediately. She promised in her letter to help the Gloucester School pupils to make friends with children in a Moscow school. She also sent a present – an illustrated book about everyday life in the Soviet Union.